-06
IN,

Richmond

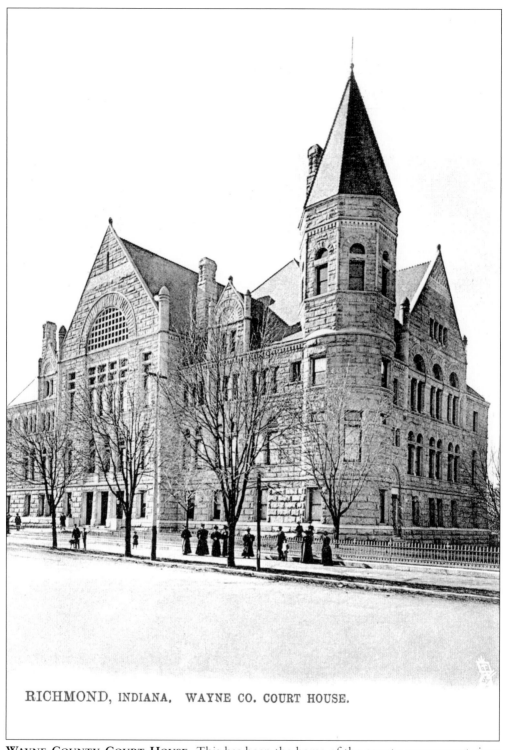

RICHMOND, INDIANA, WAYNE CO. COURT HOUSE.

WAYNE COUNTY COURT HOUSE. This has been the home of the county government since 1893 (see page 32).

POSTCARD HISTORY SERIES

Richmond

Susan E. King

Published by Arcadia Publishing
Charleston SC, Chicago IL, Portsmouth NH, San Francisco CA

Printed in Great Britain

Library of Congress Catalog Card Number: 2005932039

For all general information contact Arcadia Publishing at:
Telephone 843-853-2070
Fax 843-853-0044
E-mail sales@arcadiapublishing.com
For customer service and orders:
Toll-Free 1-888-313-2665

Visit us on the Internet at http://www.arcadiapublishing.com

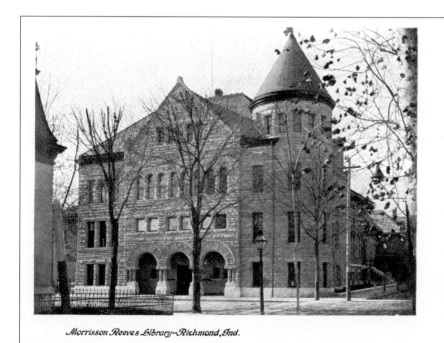

Morrisson Reeves Library-Richmond, Ind.

MORRISSON-REEVES LIBRARY. Opened in 1864, Morrisson-Reeves is the second oldest public library in the state and the sponsor of this book (see page 36).

CONTENTS

ACKNOWLEDGMENTS

Most of the images used in this book were taken from the postcard collection of the Morrisson-Reeves Library, but some were borrowed. Gary Batchelor, a frequent researcher at Morrisson-Reeves who has been collecting Richmond material for more than 20 years, graciously loaned his cards. I also received assistance from Dr. Thomas Hamm at the Earlham College Archives, Jim Harlan at the Wayne County Historical Museum, Connie Taylor at Richmond State Hospital, Ralph Pyle, and Monte Muff. Any cards not deriving from the Morrisson-Reeves collection are noted as such. I thank Carol McCafferty for editing the text.

The bulk of the information in this book came from the local newspaper *Palladium-Item* and its many predecessors. I also used pamphlet files, city directories, and items from the library's Richmond Collection, as well as the best new resource for local history, *Richmond Indiana: Its Physical Development and Aesthetic Heritage to 1920* by Mary Raddant Tomlan and Michael A. Tomlan.

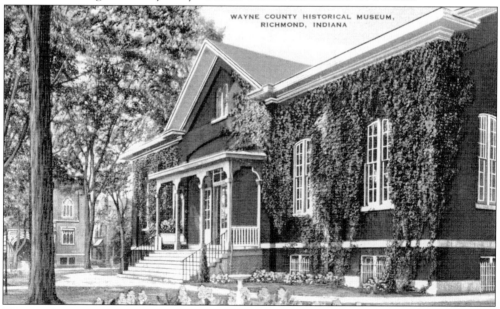

WAYNE COUNTY HISTORICAL MUSEUM. This Quaker meeting house became the museum in 1930 (see page 100).

INTRODUCTION

In the spring of 1806, David Hoover set off to the west from his father's home near Dayton, Ohio, in search of a place to make a new settlement. The Hoovers were Quakers who had left North Carolina some years before and come to the Northwest Territory to start new lives where land was fertile, inexpensive, and free of the abhorrent practice of slavery. They were not alone. Hundreds of other Quaker families were making the same journey north. The Hoovers were not satisfied with the land in Ohio, so David, after making several unsuccessful explorations, followed a section line west until he came to a river that cut a deep gorge in the fossil-laden limestone. He recorded in his memoirs years later that "[s]pring water, timber, and building rock appeared to be abundant, and the face of the country looked delightful." So was born the settlement that would become the city of Richmond.

At the time of this writing, Richmond is preparing to celebrate its bicentennial, and this book is the contribution of Morrisson-Reeves Library to that event.

None of the postcards in this book feature people, with one exception, and it appears on the following page. It is a card issued in 1939 for the 75th anniversary of the founding of the Morrisson Library. It is a facsimile of a life-sized painting commissioned in appreciation of the subject's generosity, which hung in that library's Reading Room from 1865 to 1975, and from 1975 to the present has been displayed prominently in the library's new building.

Robert Morrisson was one of this tide of North Carolina Quakers, arriving around 1810 with only the necessities for survival but rising to become one of Richmond's most famous citizens. In 1815, he opened a general store and later became the town's first postmaster. He opened the first drugstore and first hardware store before retiring from trade and concentrating his energies on banking, opening the Citizens' Bank on the corner of Main and Pearl Streets in 1853. In 1864, a year before his death, he gave $12,000 for the land and the building and another $5,000 for books, and founded the library which remains the second oldest public library in the state.

Morrisson's influence lasted past his death. In his will, he left $10,000 to the city of Richmond, with the interest to be used for charitable purposes for 40 years. For many years, the Orphans Home in West Richmond and the Margaret Smith Home for Aged Women were funded primarily by this bequest. At the end of 40 years, in 1905, the principal was to go to the city to be used as it saw fit. At that time, Richmond was following the construction of the new hospital just north of town, financed primarily by another frequent benefactor, Daniel Gray Reid. Morrisson's $10,000 then went into the Reid Memorial Hospital fund. One hundred years later, the hospital is celebrating its centennial, and it is once more in the midst of a massive construction project, again north of town, to build an entirely new hospital.

The reader should know at the start of this book that it is not a comprehensive history; it is a postcard history. The content is driven entirely by the postcards. Because these did not exist until about 1900, none of the scenes presented here depict the 19th century, although some events of that era are mentioned. Additionally, most of the images are from the early part of the 20th century. There are innumerable important and exciting topics and events from Richmond's history which are completely omitted, and that is for the simple reason that no postcard was available. If the reader would like to learn more about any of these topics, information of all sorts is available at Morrisson-Reeves Library.

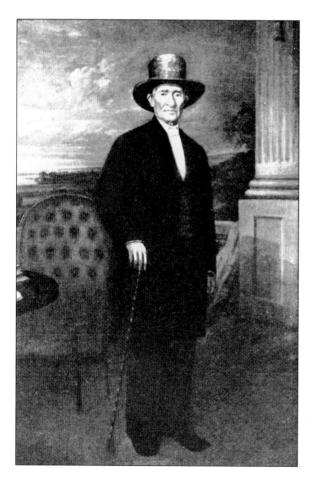

ROBERT MORRISSON, 1786–1865. The founder of the Morrisson Library was painted by John C. Wolfe and Marcus Mote in 1864.

One

BRIDGES AND RIVERS

The Whitewater River has shaped the course of Richmond's history. At first, the deep gorge it cut was a great obstacle to westward migration. Travelers, often in Conestoga wagons, had to descend into the gorge, travel downstream to a point where the river was shallow enough and the bottom hard enough to ford, then either try to scale the bluff on the west side or travel another few miles downstream where the westerly grade was less steep.

In the 1830s, the federal government remedied this situation with the construction of the National Road and bridge. The road and bridge increased the immigrant traffic across Wayne County, but not all those immigrants continued west. Many of the Germans who labored to build the bridge remained in Richmond, settling mostly south of Main Street.

As the population grew and engineering methods improved, more bridges spanned the river and its tributaries all over the area to ease travel, whether across town or across the country.

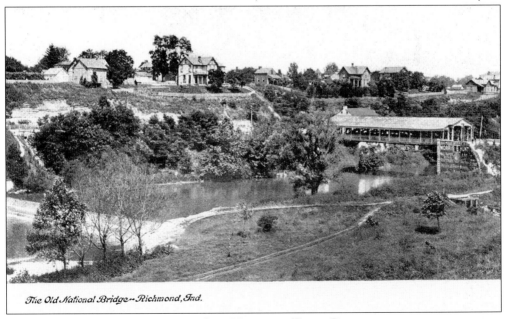

The Old National Bridge~Richmond, Ind.

WHITEWATER RIVER GORGE AND OLD NATIONAL ROAD BRIDGE.

9

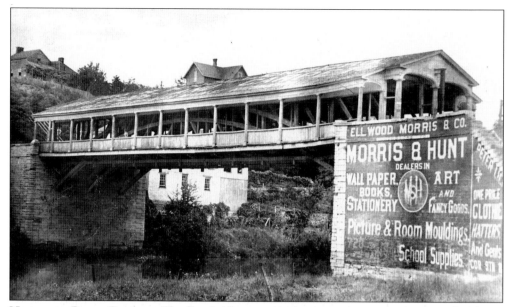

NATIONAL ROAD BRIDGE. The first bridge to span the gorge was an engineering feat for its time at 120 feet long with a height above water of 30 feet. The funds were appropriated in 1832, and construction began in 1833. The stone for the abutments had to be hauled from Abington in the southern part of the county, and all the timbers and bolts were prepared on site. When it was complete, the span was considered the finest bridge on the National Road. It was closed to traffic in 1895.

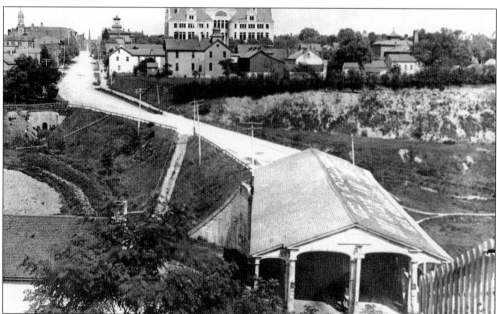

NATIONAL ROAD BRIDGE, LOOKING EAST. This view of the approach to the National Road Bridge is seen from the bluff on the west side. The photograph for this postcard was taken during the construction of the 1893 Wayne County Courthouse. The spire just to its left is that of the 1873 courthouse, which was subsequently demolished. The tower in the upper left corner is that of the 1886 city hall (see page 34).

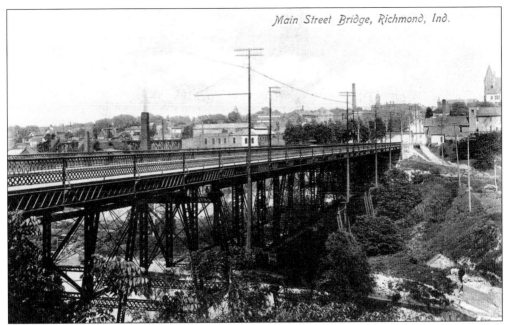

MAIN STREET BRIDGE (STEEL), LOOKING NORTHEAST. This card shows the second steel bridge with the abutment for the 1834 bridge still visible the lower right corner. It was completed in June 1897 to specifications laid out in 1896. At that time, the electric-powered interurbans that regularly used the bridge were relatively light, but they did not remain so. Increases in the size and numbers of the trolley cars, as well as an increase in all traffic, contributed to the excess strain on the bridge.

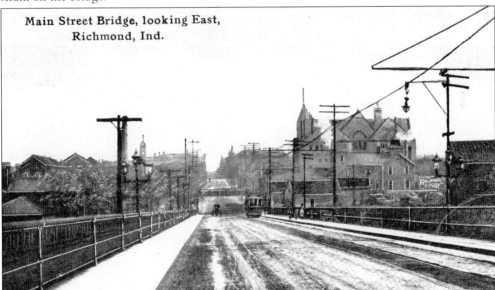

MAIN STREET BRIDGE (STEEL). Looking across the steel bridge, this view includes the courthouse, Minck Brewery, and an interurban car. By 1915, many of the steel girders had corroded, forcing the city to close the bridge in August. The Terre Haute, Indianapolis, and Eastern Traction Company, which operated the interurbans over the bridge, was outraged by the closure, especially when the electricity used for its cars was blamed for accelerating the rust.

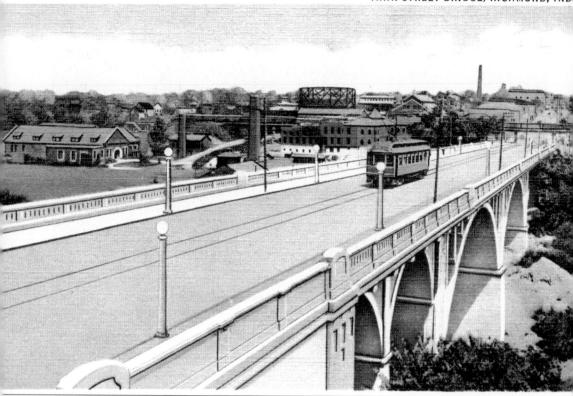

MAIN STREET BRIDGE (CONCRETE). The next structure to span the Whitewater was the concrete Main Street Bridge. Construction on this bridge began in September 1917, but World War I interrupted the progress by claiming material and labor for war industries. Construction continued intermittently until the bridge opened in the summer of 1920. This card gives a good view of the Municipal Electric Lighting and Power plant and the old gasworks building, which still exists. This bridge remained in service until 2000, when the U.S. Route 40 Bridge at South A Street opened. Torn down in 2002, the concrete span was rebuilt in the same location and opened in October 2004.

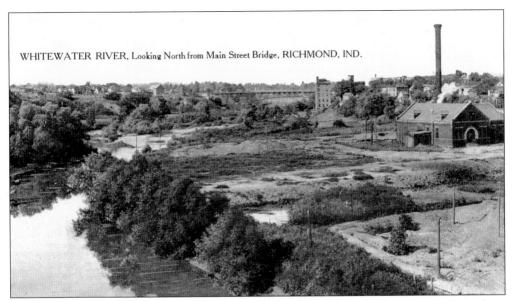

WHITEWATER RIVER, Looking North from Main Street Bridge, RICHMOND, IND.

WHITEWATER RIVER, LOOKING NORTH FROM THE MAIN STREET BRIDGE. To the right in this view is the Municipal Electric Lighting and Power plant, and in the distance are the Doran Bridge and the Richmond Roller Mill buildings.

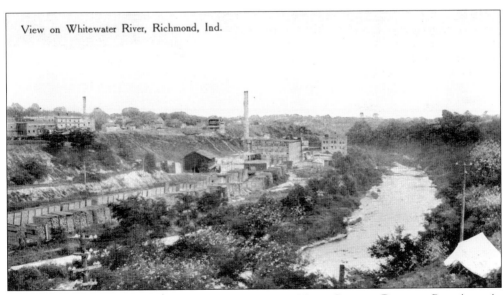

View on Whitewater River, Richmond, Ind.

WHITEWATER RIVER, LOOKING SOUTH FROM THE MAIN STREET BRIDGE. Prominent in this image of the river is the Starr Piano Company complex.

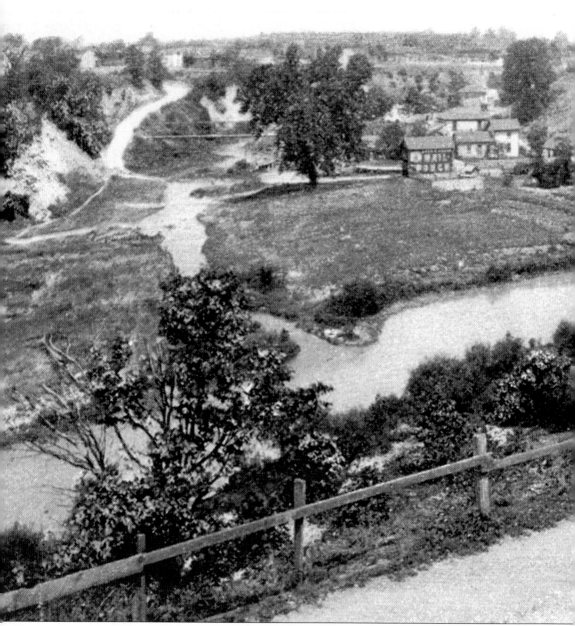

HAPPY HOLLOW. Shown here in a northwest-facing view, Happy Hollow is the valley in which the West Fork joins the East Fork of the Whitewater River. Two bridges appear in this image. The one to the right was known as either the Happy Hollow Bridge or the Gaar Bridge, because it led from the hollow up to the Gaar, Scott, and Company complex. This bridge was completed

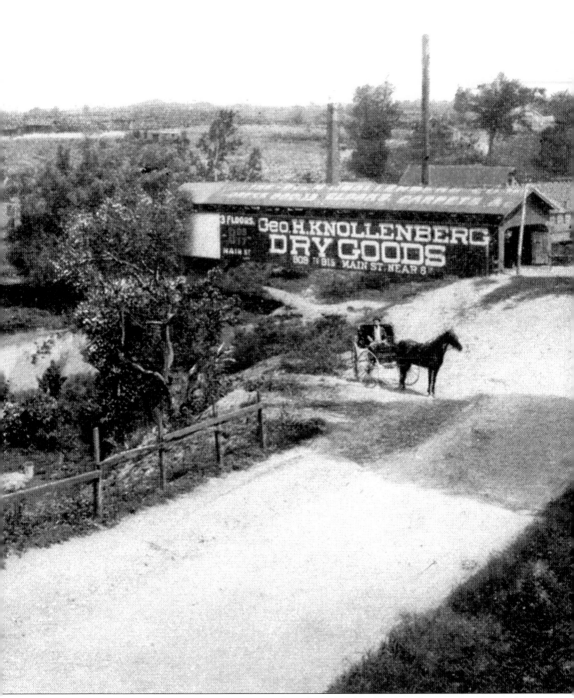

in 1858 and removed in 1931. In the distance to the left is a bridge that later became known as the Brannon Bridge. Barely seen behind the Gaar Bridge is the Nixon Paper Mill, one of Richmond's oldest industries. It began production in 1830, but eventually fell prey to a changing economy and the ravages of frequent fires and floods. It did not survive the 1913 flood.

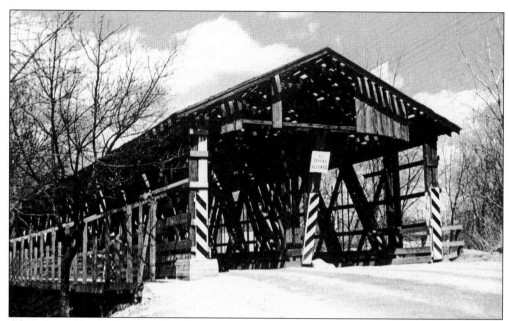

BRANNON BRIDGE. Crossing the West Fork in Happy Hollow, this bridge was built around 1860. At the time of its collapse in May 1958, it was one of only two double-barrel spans remaining in Indiana. It was replaced by a concrete bridge in 1961.

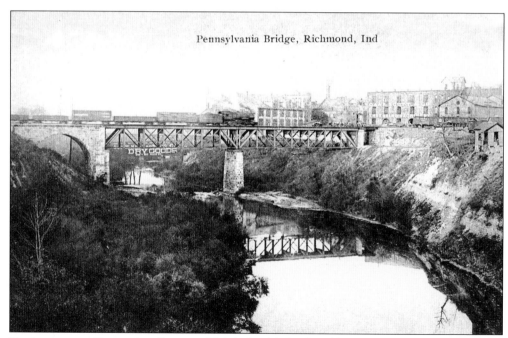

Pennsylvania Bridge, Richmond, Ind

PENNSYLVANIA RAILROAD BRIDGE. This is the third railroad bridge at this location. The first, built in 1852 and burned in 1870, was replaced by a steel single-track bridge, which was then replaced by this one in 1902–1903. It is still in use today. (Courtesy of Gary Batchelor.)

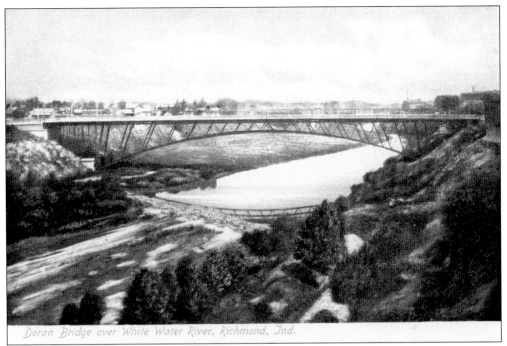

Doran Bridge over White Water River, Richmond, Ind.

DORAN AND TWENTIETH CENTURY BRIDGES. Named for the city engineer who designed it, the Doran Bridge (above) was completed in 1885. It was made primarily of wrought iron and spanned a total length of 516 feet, reportedly the longest of its kind in the world at the time. It joined North D Street to Richmond Avenue and provided easier access to the suburbs on the west side of the river, encouraging their growth. It remained in service until 1948, when the city finally deemed it unsafe and closed it. It was dismantled in the summer of 1950 and was replaced by the Twentieth Century Bridge (below).

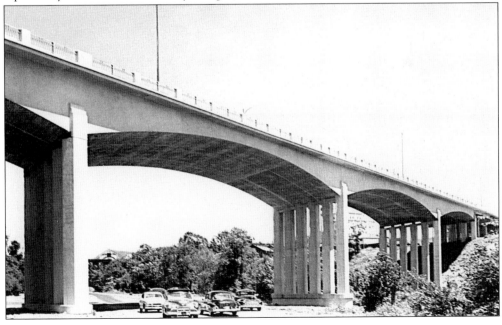

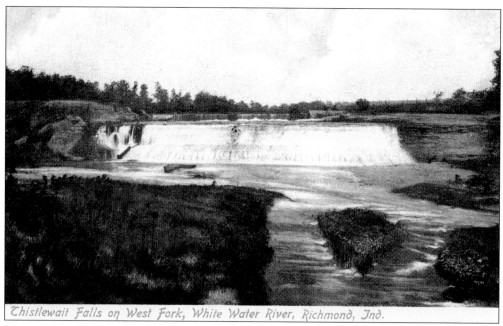

Thistlewait Falls on West Fork, White Water River, Richmond, Ind.

THISTLETHWAITE FALLS. The falls are located just south of Waterfall Road near Springwood Lake. In the early 1800s, Timothy Thistlethwaite blasted a new channel in the West Fork to direct the water over this rock formation and provide more waterpower to his nearby sawmill.

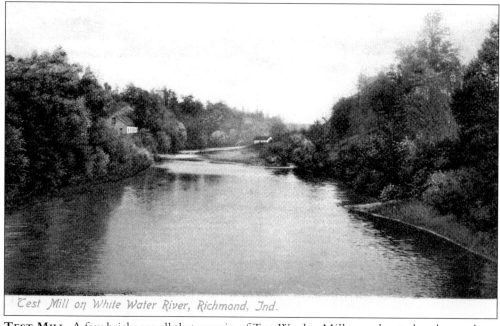

Test Mill on White Water River, Richmond, Ind.

TEST MILL. A few bricks are all that remain of Test Woolen Mill, now located at the southern entrance to the Cardinal Greenway Trail near the point where Test Road crosses the river.

18

Two

TRANSPORTATION
AND TRAVEL

For many towns, close proximity to a river meant access to greater transportation opportunities, but the Whitewater River was too shallow to be navigable. The canal craze of the 1830s and 1840s mostly affected the western part of Wayne County, making Richmond more than ready for the advent of railroads. The first locomotive arrived in 1853, and Richmond's first large depot opened in 1872.

The local streetcars transported passengers around town, and the interurban lines carried passengers and light freight to other cities. These electric-powered conveyances were extremely popular before World War II. Additionally, most of the travelers needed a place to stay, and Richmond was well-supplied with some of the best accommodations in the state. Beginning in the 1920s, when more and more families owned cars and took to the road on vacations, the old National Road, by now known as U.S. Route 40, again became a major thoroughfare, and it was dotted with new "motor hotels," or motels.

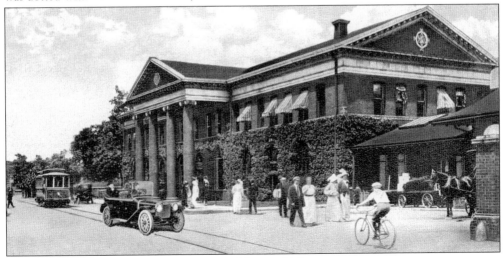

PENNSYLVANIA RAILROAD STATION AND NORTH E STREET.

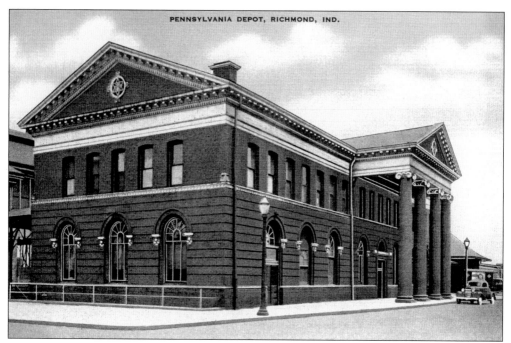

PENNSYLVANIA DEPOT. One of the most notable structures in Richmond is the passenger depot on North E Street near Tenth Street, which was built in 1901–1902 and designed by the famous Chicago firm of D. H. Burnham and Company. On the first floor, the depot housed large waiting areas, a lunch counter, and ticket, telegraph, and baggage offices, with other offices on the second floor. The station was one of the busiest spots in town for much of its active life, accommodating dozens of trains a day. The decline of rail service closed the depot in the 1970s, and the building remains vacant today.

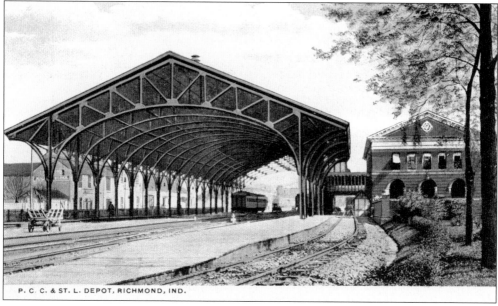

P. C. C. & ST. L. DEPOT, RICHMOND, IND.

TRAIN SHED. This iron and glass shed to the north of the depot was capable of loading nine trains at a time. It was torn down in 1953, prior to the construction of the Ninth Street overpass.

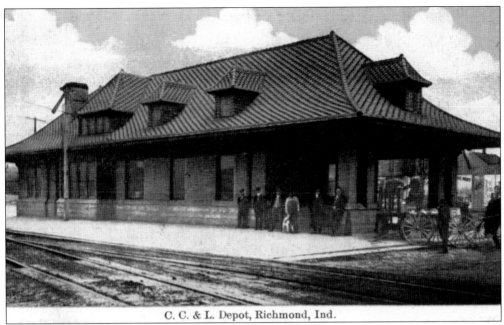

C. C. & L. Depot, Richmond, Ind.

CINCINNATI, RICHMOND, AND MUNCIE STATION. These two images, showing the same depot, illustrate the process of consolidating many small rail lines into larger ones. Built in 1901 for the Cincinnati, Richmond, and Muncie line, this passenger station was located at North Third and C Streets. In 1903, it became part of the Cincinnati, Chicago, and Louisville line before that line was bought by the Chesapeake and Ohio system in 1910. This structure, too, is now vacant and sits at one of the entrances to the Cardinal Greenway Trail. (Below courtesy of Gary Batchelor.)

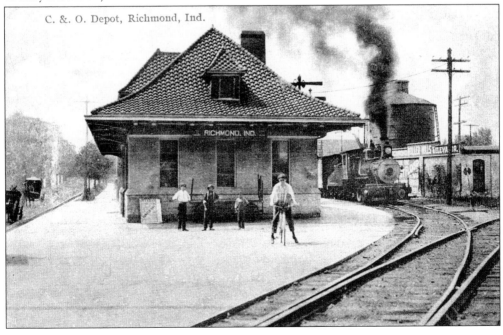

C. &. O. Depot, Richmond, Ind.

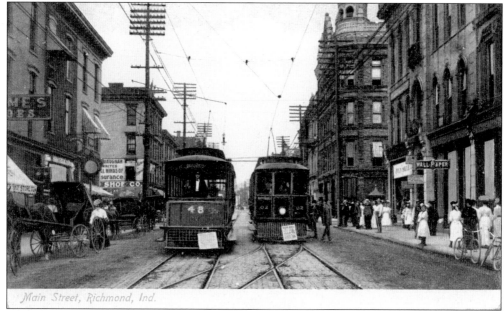

Main Street, Richmond, Ind.

INTERURBANS. The electric interurban railway system was an extremely popular form of transportation that carried passengers to other cities. The interurbans ran quickly and often, and fares were inexpensive. A system of rails was laid across much of the Midwest in a few short years, making it easy for Richmond residents to get to Terre Haute, Indianapolis, or Dayton, Ohio, or any place in between. In order to entice even more passengers, interurban companies often bought or developed parks and other amusements, like Jackson Park just west of Centerville. The cars were also able to carry limited freight loads, which amounted to sort of an express service. Interurbans were common sights on Richmond streets, and most views from this era, like the two on this page, show streetcars or tracks.

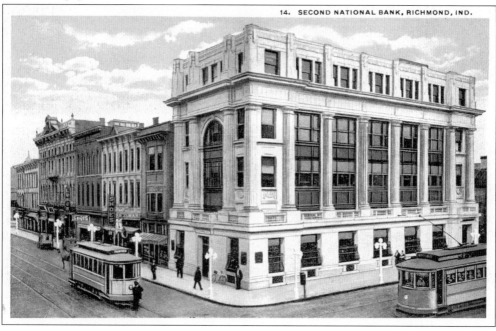

14. SECOND NATIONAL BANK, RICHMOND, IND.

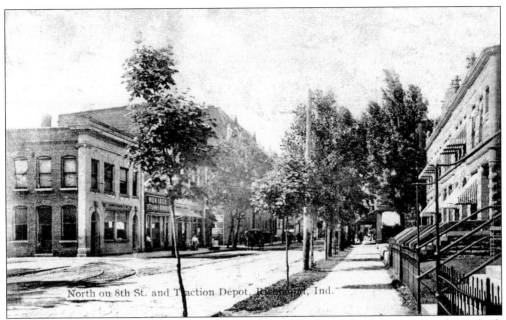

North on 8th St. and Traction Depot, Richmond, Ind.

INTERURBAN STATION. The building on the far left of this postcard is the interurban depot. Built in 1903, it served as a station for the interurban lines running both west to Indianapolis and east to Dayton. When this service ended in 1937, the building was converted to a Greyhound bus terminal. It was torn down in 1962 to make room for a parking lot. (Courtesy of Gary Batchelor.)

BUSES. The last streetcar ran in Richmond on April 23, 1938, and the next day city bus service took over. The buses, like this one traveling east at Sixth and Main, still bore the name of Indiana Railroad.

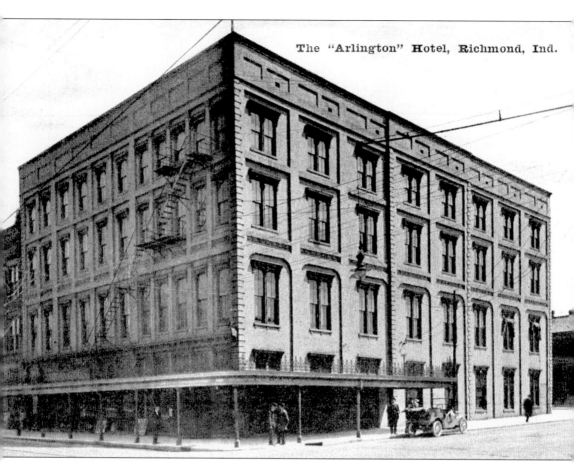

The "Arlington" Hotel, Richmond, Ind.

ARLINGTON HOTEL. The building at North Ninth and E Streets first became a hotel in 1877 and was remodeled in 1888. Its location across the street from the depot made it a popular spot for travelers, and during World War II, it was the home of the USO. The construction of the Ninth Street overpass in 1952–1954 caused so much disruption that it was no longer viable as a hotel. In 1956, the Adam H. Bartel Company bought the hotel, which stood just next door to its North E Street facility, and razed it to allow for a parking lot (see page 52).

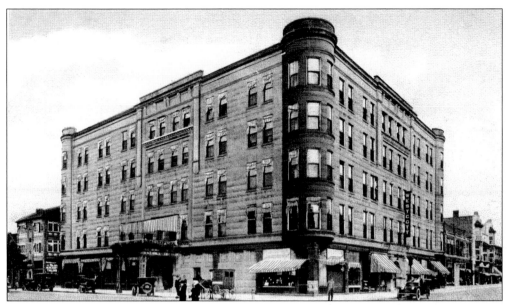

WESTCOTT HOTEL. Located on the northeast corner of Tenth and Main Streets, the Westcott Hotel was intended to be the "premier hotel of Indiana" in its heyday. The grand opening was September 10, 1895, and all the biggest names in the city were guests that night. The Commercial Club spearheaded the drive to build it and owned it until 1899, when the club fell on hard times. J. M. Westcott, an early Richmond business leader and the man for whom the hotel was named, then assumed ownership.

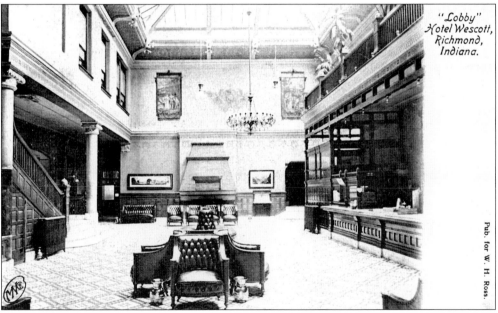

WESTCOTT HOTEL LOBBY. The interior of the hotel boasted some of the finest features available at the time, including a marble staircase, electric elevator, and sunlit lobby, seen here. By the 1970s, the hotel was no longer a premier lodging, and with the interstate highway system, tourists were no longer driving on U.S. Route 40 through town. The Westcott closed in 1976 and was razed in 1977. (Courtesy of Gary Batchelor.)

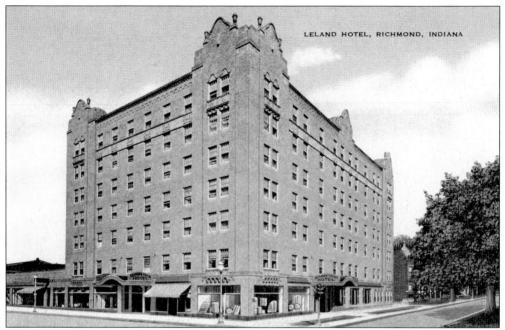

LELAND HOTEL. Situated on the northeast corner of Ninth and South A Streets, this hotel was opened in September 1928. Visiting dignitaries such as President Truman stayed here, and its ballroom played host to special events and high school reunions over the years. In 1964, the hotel became the Leland Motor Inn to keep up with changing modes of travel and tourism. In 1985, it was placed on the National Register of Historic Places and, for a time in the 1990s, became a part of the Clarion hotel chain. It closed in 2000 but was remodeled into senior apartments and reopened the following year.

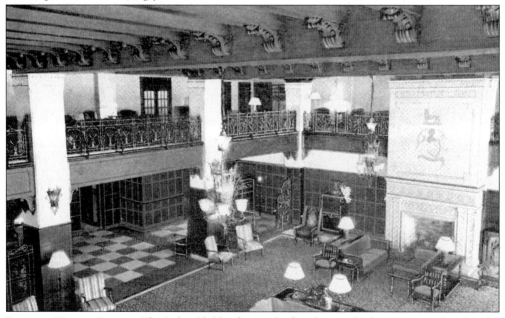

LELAND HOTEL LOBBY. The Leland lobby featured a fireplace and what was considered at the time to be the largest rug ever brought to Richmond, at 180 square yards and 1,200 pounds.

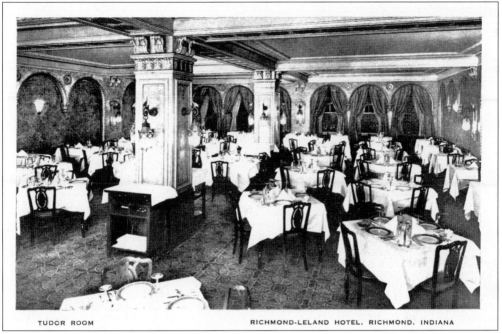

TUDOR ROOM RICHMOND-LELAND HOTEL, RICHMOND, INDIANA

TUDOR ROOM. At its opening in 1928, the Leland Hotel's main dining room contained 46 tables seating 186 people.

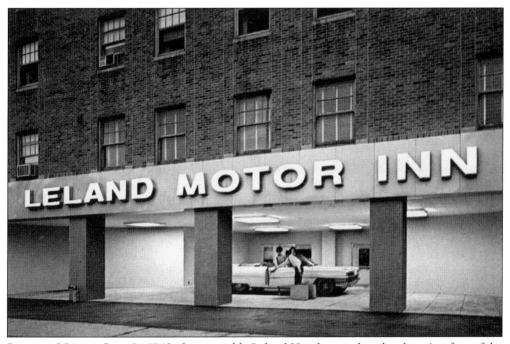

LELAND MOTOR INN. In 1963, the venerable Leland Hotel reacted to the changing face of the hotel business and became a motel. Its lobby was gutted to make a drive-in entrance for motorists. Motels had become the norm many years earlier along the old National Road.

Fifteen Air-con-
ditioned rooms.

Shower and tub
baths.

Protected Park-
ing facilities.

PLEASANT VIEW INN

"THE TOURIST INN THAT IS DIFFERENT"

Excellent Meals at the Tourist Home adjoining

—RATES—
$1.00 & 1.50
per Room

PLEASANT VIEW INN. Listed as "5 miles east of Richmond, Ind., on U.S. 40," this lodging is an early example of a tourist inn used by motorists traveling on the old National Road.

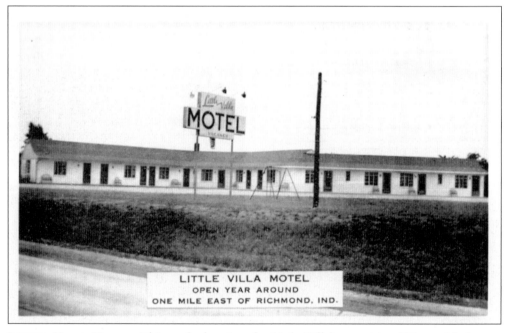

LITTLE VILLA MOTEL
OPEN YEAR AROUND
ONE MILE EAST OF RICHMOND, IND.

LITTLE VILLA MOTEL. This card advertises the Little Villa's amenities: "New—Modern—Fireproof—Private Baths, Tub or Shower—Hot Water Heat—Cross Ventilation—Simmons Mattresses—Near Good Restaurant." The motel was located on U.S. Route 35 at its intersection with U.S. Route 40.

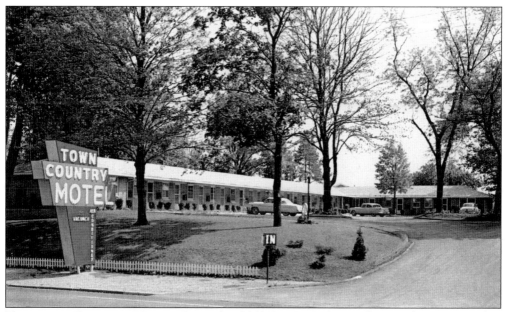

TOWN AND COUNTRY MOTEL. Located at 3643 East Main Street, this motel was removed in 1993 to clear the way for the new South Thirty-seventh Street.

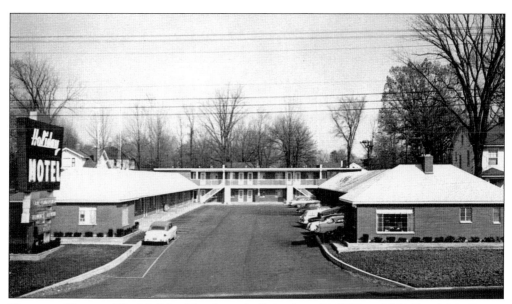

HOLIDAY MOTEL. The Holiday Motel was built in the mid-1950s at 3004 East Main Street, and remains a motel today.

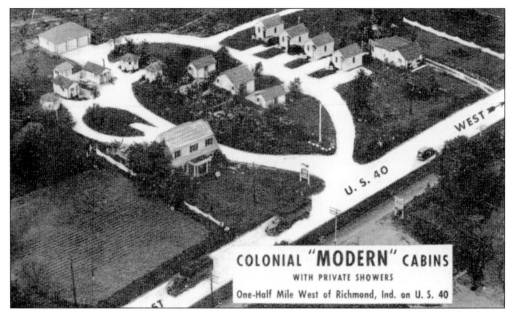

COLONIAL "MODERN" CABINS. These cabins catered to weary travelers at 2437 National Road West until the early 1970s.

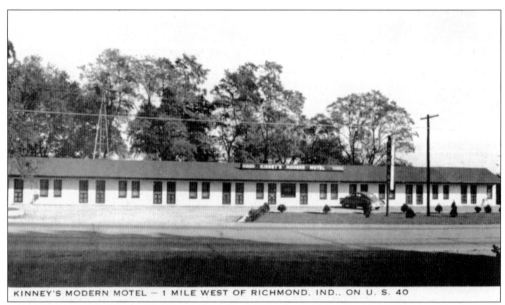

KINNEY'S MODERN MOTEL. This lodging was located at 4016 National Road West and was later known as Porter's Modern Motel. It served as a motel until the mid-1970s, and today it is home to a florist.

Three

PUBLIC, CIVIC, AND FRATERNAL BUILDINGS

Richmond was not always the seat of Wayne County, Indiana. The first was Salisbury, a town that has since vanished from the map, followed by Centerville, which, as its name implies, is near the geographic center of the county. By the early 1870s, the businessmen of Richmond were working to locate the county government in the area they considered the commercial and transportation center of the county. In 1873, after much legal wrangling—and a bit of gunfire—the county seat moved six miles eastward to Richmond. The pace of the city's growth only increased; therefore, it had some of the largest civic and fraternal organizations in the state, many of which built large and impressive structures, like the Masonic temple shown here. These two landmarks were located on the southern corners of North A and Ninth Streets.

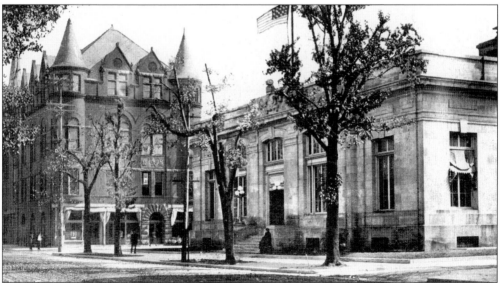

MASONIC TEMPLE AND POST OFFICE.

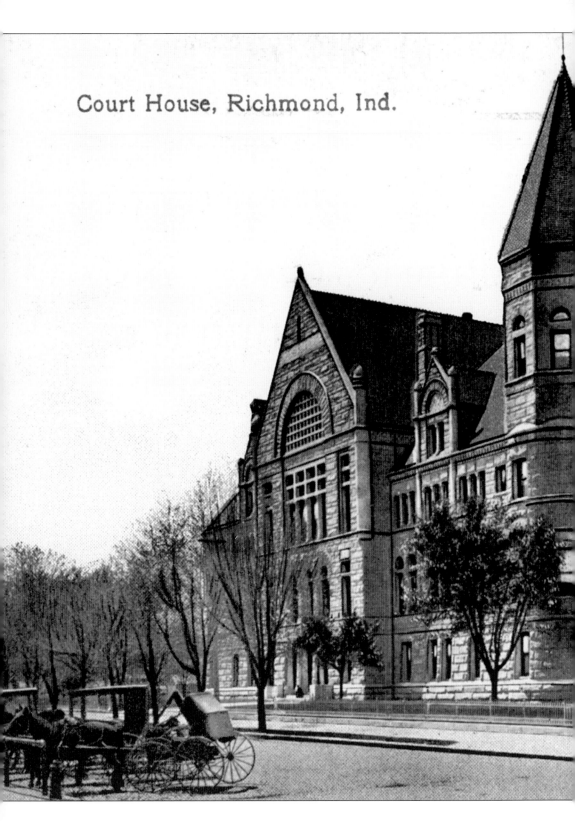

Court House, Richmond, Ind.

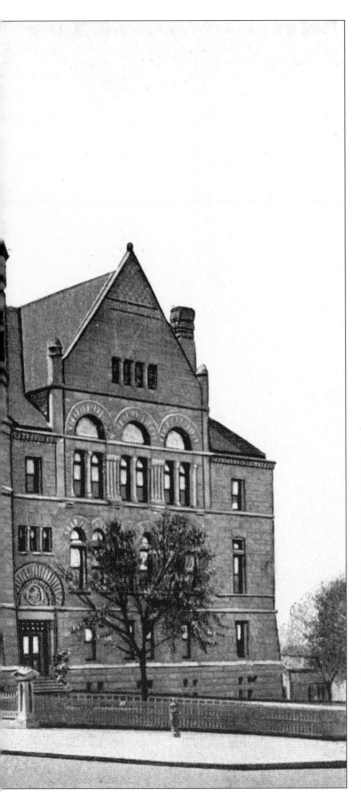

WAYNE COUNTY COURTHOUSE. The first county courthouse in Richmond was built in 1873, just before the county government had arrived from Centerville. Though intended as a temporary building, it would be 20 years before a permanent facility would take shape. Architect James McLaughlin designed an imposing Romanesque Revival structure, and contractor Aaron Campfield built it from 1890 to 1893. The exterior is composed of granite from Concord, New Hampshire, and Bedford stone. The original roof was red tile but was recently replaced with slate. The building was dedicated in February 1893 and is still in use today. It remains the most recognizable structure in the county.

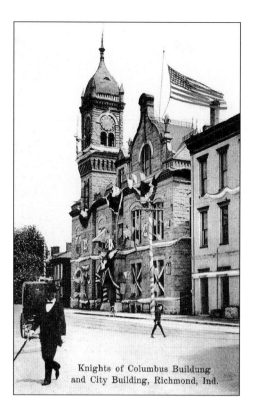

Knights of Columbus Buildung
and City Building, Richmond, Ind.

KNIGHTS OF COLUMBUS AND CITY BUILDING. In 1903, the Knights of Columbus bought the building on the northwest corner of Fifth and Main Streets, the rear of which is seen in this card. The structure had been built in 1856 for Robert Morrisson to house his Citizen's Bank. The city hall, here decorated for a special occasion, was dedicated in January 1886 and had multiple uses. The northern part of the building served as Hose House No. 2 of the Richmond Fire Department. It was razed in 1970 after the city government moved into its new building on the west side of Fifth Street between Main and North A Streets. (Courtesy of Gary Batchelor.)

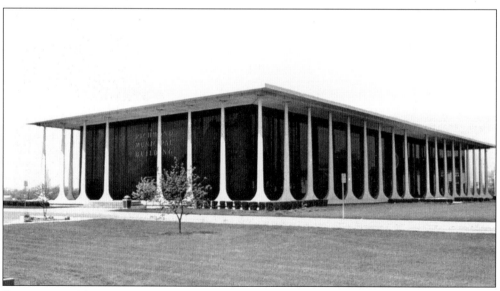

RICHMOND MUNICIPAL BUILDING. Since 1969, this site has been the home of the city government.

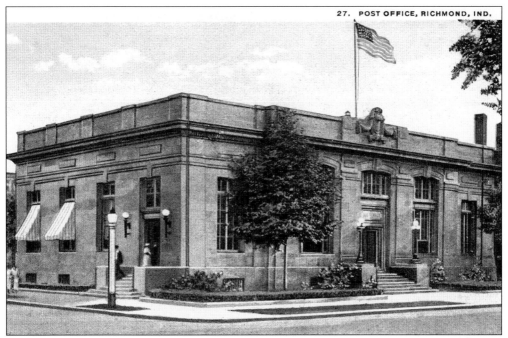

POST OFFICE. Built in 1905 on the southwest corner of North A and Ninth Streets, this building housed the post office until 1971, when a new facility was constructed just four blocks down North A at Fifth Street. Since 1976, it has housed the Indiana Football Hall of Fame.

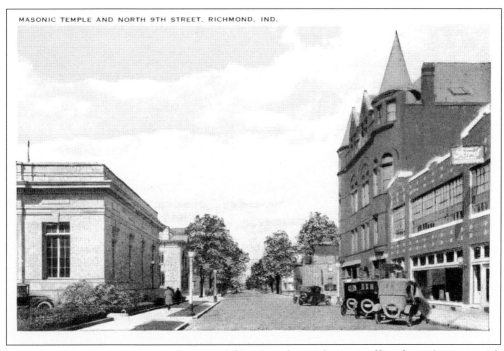

MASONIC TEMPLE AND NORTH 9TH STREET, RICHMOND, IND.

LOOKING NORTH ON NINTH STREET. This view shows the post office from the rear, with the Masonic temple across the street.

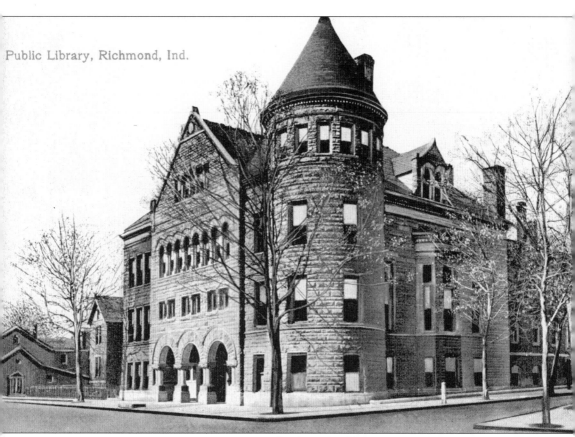

Public Library, Richmond, Ind.

MORRISSON-REEVES LIBRARY. Originally the gift of businessman Robert Morrisson, the Morrisson Library opened on July 30, 1864, on the southwest corner of what was then Broadway and Marion Streets with 6,000 volumes in a single reading room and a single librarian. In 1893, Caroline Middleton Reeves donated $30,000 to expand and renovate the original building, and to add her family's name to the library. Shown here is the 1893 version of the library, with its distinctive tower, arched entryway, and bay on the north side that included the Tiffany window donated by Robert Morrisson's great-grandchildren. The library remained at its North A and Sixth Street location until 1975, when a new facility was built just to the south. Before demolition of this building, workers salvaged many architectural pieces, such as stones, floor panels, and the iron spiral staircase that provided access to the balcony of the Reading Room, and installed them in various places in the new building, where they can be seen to this day.

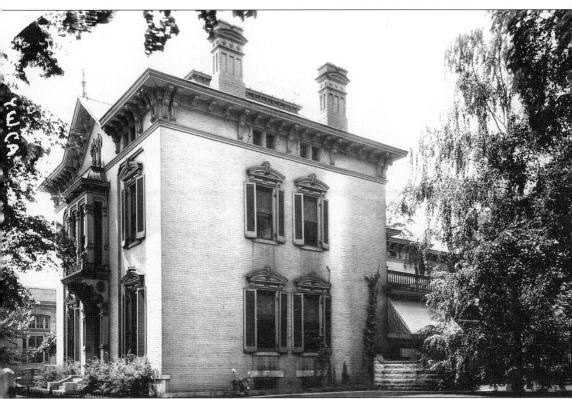

YWCA. Banker and philanthropist Robert Morrisson purchased this house in 1853, when it was one of the newest and most fashionable houses in Richmond. His son James lived in it, and later James's daughter Elizabeth lived here with her husband, Elgar G. Hibberd, son of Mayor Dr. James F. Hibberd. The YWCA bought "the Hibberd place" in February 1926 and, in 1954, added another building and faced this one with brick to match. The organization moved from this building in 1984 and sold it in 1985. It now serves as a ministry center.

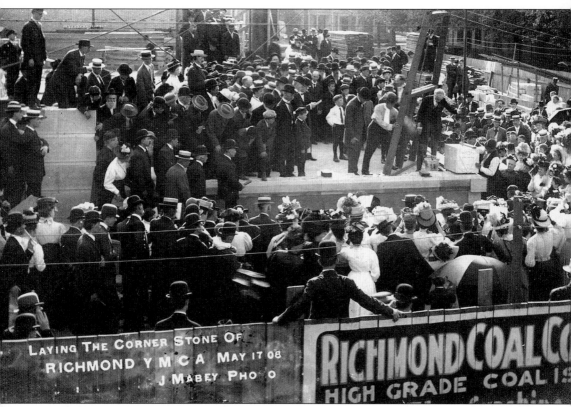

LAYING THE CORNERSTONE. Community leaders worked for five months to raise the necessary $100,000 to build the new YMCA building. On May 1, 1907, the *Evening Item* proclaimed that "Richmond Will Have A Y.M.C.A." and related the contributions of more than 3,000 citizens—from boys who donated coins and dollars to Daniel G. Reid, who pledged $15,000. By the following May 17, the cornerstone-laying ceremony was conducted, preceded by a program of speeches at the Gennett Theatre across the street. Laying the stone in this image is Adam H. Bartel, chairman of the board of trustees. (Courtesy of Gary Batchelor.)

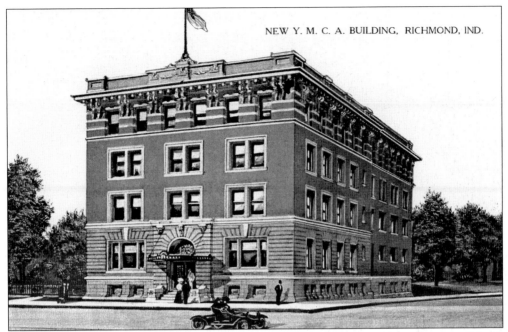

NEW Y. M. C. A. BUILDING, RICHMOND, IND.

"New" YMCA Building. The completed building, located on the southwest corner of North A and Eighth Streets, was dedicated on December 27, 1908.

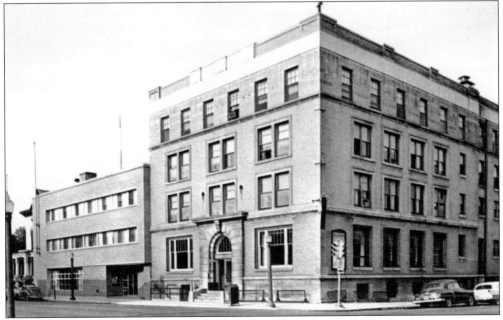

YMCA, 1956. By the 1950s, the organization needed more space for its programs and therefore planned an addition to the south. The dedication for this building took place on June 17, 1956. A 1975 renovation altered the interior and added the aluminum façade on the Eighth Street side of the building, which exists today.

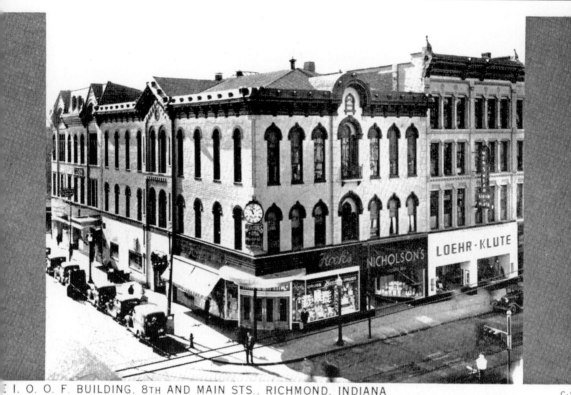

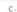

INDEPENDENT ORDER OF ODD FELLOWS HALL. Located on the southwest corner of Eighth and Main, or U.S. Routes 27 and 40, the IOOF Hall has been a fixture at the busiest corner in town for most of Richmond's existence. The Independent Order of Odd Fellows, a fraternal group, built its new hall in 1868 and dedicated it early the next year. The lodge occupied the third floor, the second floor contained offices, and the first floor housed retailers. The Nicholson Brothers Book Store was one of the first tenants, operating at 729 Main from 1869 to 1943.

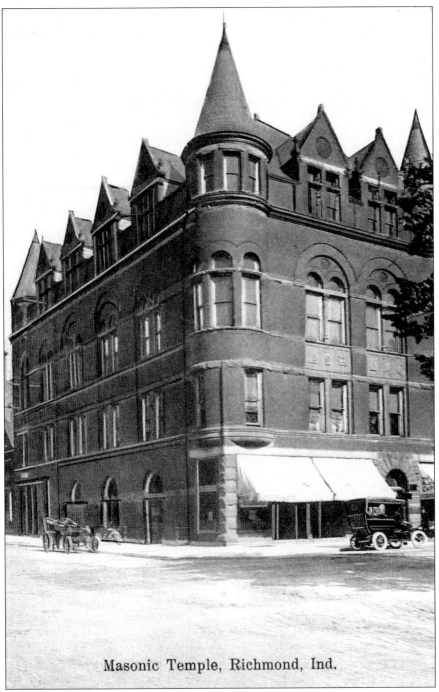

Masonic Temple, Richmond, Ind.

MASONIC TEMPLE. This structure, on the southeast corner of North A and Ninth Streets, was built in 1894 and dedicated in January 1895. In addition to the upper-floor lodge rooms, the lower floors provided rental income. The first tenant was the U.S. Post Office, which occupied part of the first floor until 1905, when its new building was completed across the street, followed by the *Richmond Palladium*, which occupied it until 1916. It was also the home of the Commercial Club for much of that group's existence. The temple was torn down in 1969.

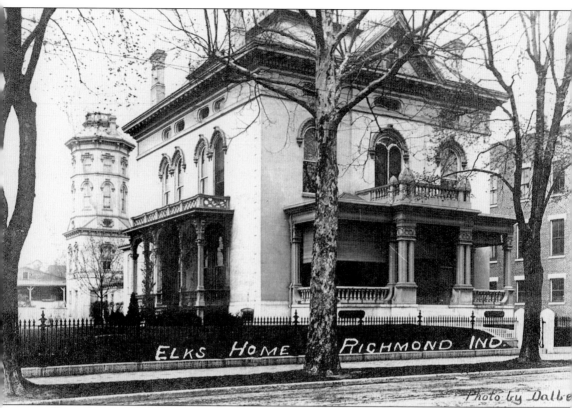

ELKS LODGE. This house was built in 1859 for tobacco merchant John Bridgland. John M. Gaar bought it in 1866, adding the distinctive four-story water tower in the rear. The local Elks Lodge bought it from Gaar's widow in 1907 and used it as a "City Club" until 1963, when the group bought land south of town for a combined lodge and golf course. This building was razed in January 1964 to allow for a "motor bank" and parking lot for the Second National Bank. (Courtesy of Gary Batchelor.)

Four

BUSINESS AND INDUSTRY

Richmond's early success in industry is at least partly a result of its geography. The Whitewater River may not have been navigable, but it was fast moving, and the drop in elevation from north to south created a great deal of power. In the days when water was the main source of power for mills, the Whitewater and its tributaries as well as abundant natural springs provided ample energy. Dr. John T. Plummer wrote in the first known history of Richmond, *Reminicsences of the History of Richmond*, that in 1857 the town had "22 Flouring Mills, 24 Saw Mills, 1 Oil Mill, 2 Paper Mills, and a large number of Woolen factories."

Although the early mills disappeared, other riverside industries, like the forerunner of the Starr Piano Company, persisted even as they outgrew their reliance on waterpower. Plentiful rail connections made Richmond an attractive place to do business for manufacturers, distributors, and retailers alike. And the town's factories produced goods that were shipped across the country and around the world. (Courtesy of Gary Batchelor.)

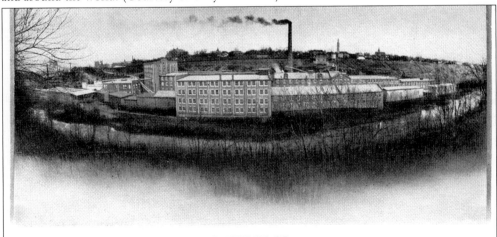

FACTORIES OF

THE STARR PIANO COMPANY

RICHMOND, INDIANA, U.S.A.

OUTPUT ONE INSTRUMENT EVERY TWELVE MINUTES

STARR PIANO COMPANY ADVERTISING CARD.

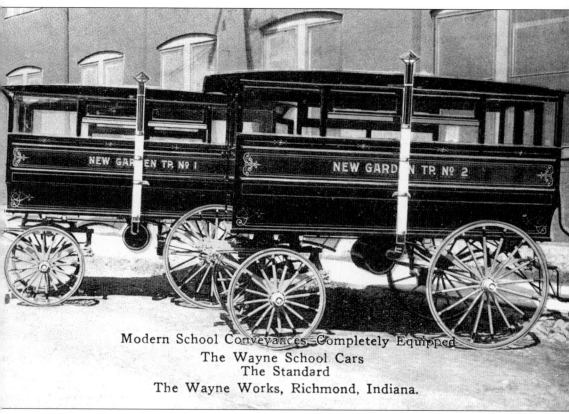

Modern School Conveyances, Completely Equipped
The Wayne School Cars
The Standard
The Wayne Works, Richmond, Indiana.

WAYNE WORKS. Beginning as the Wayne Agricultural Works in Dublin, Indiana, in 1837, this company moved to Richmond in 1876. By the 1890s, it was specializing in carriages and horse-drawn "kid-hacks," or early school buses. From 1906 to 1916, Wayne Works manufactured the "Richmond" automobile, but in 1914 the firm built its first school bus, and for most of the rest of the century, it was a major producer of buses. When the company threatened to leave in 1964, the community launched a drive to build a new plant. Opened in 1966, it was a $5 million, state-of-the-art facility. Wayne Works stayed in Richmond, but by 1993, it could no longer compete in the market and closed.

ATLAS UNDERWEAR COMPANY. Built for the Richmond Underwear Company in 1911, this building on the northeast corner of North Tenth and D Streets was sold to the Atlas Underwear Company of Piqua, Ohio, in 1915. The company provided underwear for the military during both world wars and to the astronauts in the 1960s. In 1970, the manufacturing operation was transferred to Piqua, and the building sat idle for many years. In 2001, the space reopened as the Atlas Senior Apartments.

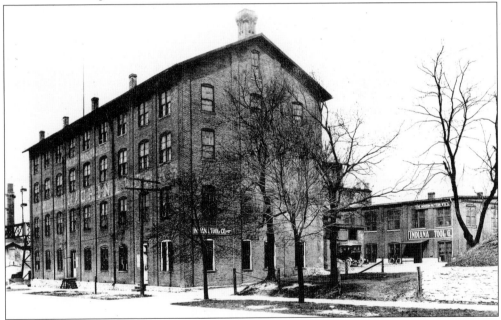

HENLEY ROLLER SKATE AND MACHINE WORKS. Owned by Micajah Henley, patent holder of the roller skate, this factory was located at North Sixteenth and F Streets, with easy access to the railroad. In addition to skates, this company manufactured bicycles, lawn mowers, and other machinery. This photograph was taken in the early 1920s, when the building was occupied by the Indiana Tool Company. (Courtesy of the Earlham College Archives.)

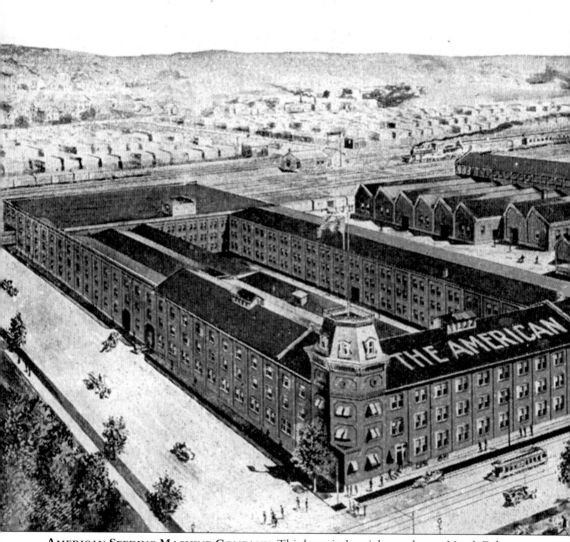

AMERICAN SEEDING MACHINE COMPANY. This large industrial complex on North E, between Thirteenth and Fifteenth Streets, became the home of the American Seeding Machine Company in 1903. Prior to that time, it was the Hoosier Drill Works, a company that had started in Milton, Indiana, and moved to this location in 1878. John M. Westcott served as president and surrounded

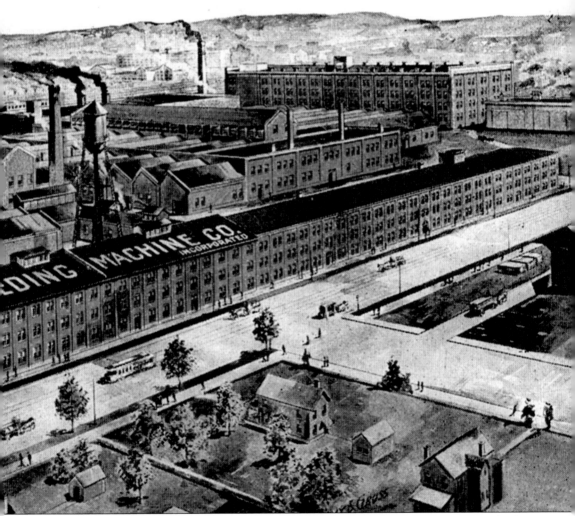

himself with his three sons-in-law as officers. At least in 1899, the company could claim to be the largest factory in the world devoted entirely to the manufacture of seeding machines. In 1920, it became the Richmond unit of the International Harvester Company, closing in 1957.

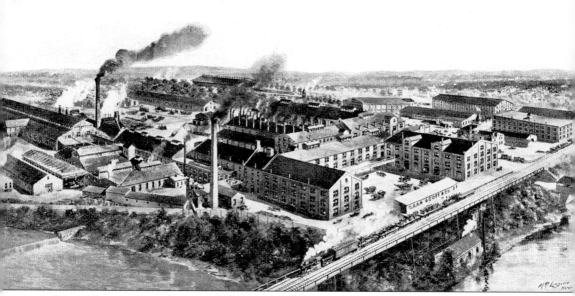

GAAR, SCOTT, AND COMPANY. This complex, located on the bluff just east of the East Fork of the Whitewater River, was one of Richmond's largest employers during the 19th century. It originated in 1836 as the Spring Foundry, and in 1849, Jonas Gaar, his sons Abraham and John, and his son-in-law William Scott bought the company. The firm produced threshing machines and traction engines, as well as other farm equipment, and its products were shipped to all parts of the world. In December 1911, the M. Rumely Company of LaPorte, Indiana, bought out the local business, then went bankrupt itself only a few years later. All of the buildings of the complex are gone, except the administration building, which now houses the offices of the Richmond Baking Company.

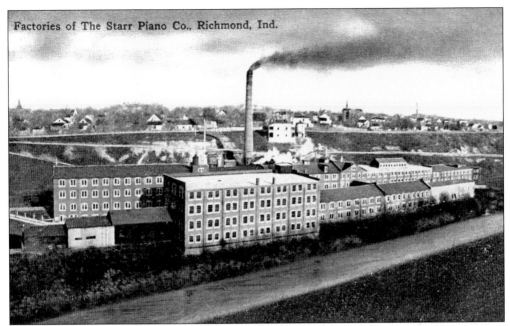

Factories of The Starr Piano Co., Richmond, Ind.

FACTORIES OF THE STARR PIANO COMPANY. The Starr Piano Company began as the Trayser Piano Company in 1872 and was reorganized as the Chase Piano Company in 1878. James M. Starr and his brother Benjamin were both involved in the early years, and when it was incorporated in 1893, it became the Starr Piano Company. In 1884, the business bought 23 acres in the Whitewater Valley gorge and constructed a six-story, water-powered factory. This factory grew into a sprawling complex of buildings and lumberyards and became one of the largest employers in Richmond. In 1915, the company also began producing phonographs and records. In fact, the Gennett Record Division made some of the earliest recordings of such musical genres as jazz, country, and blues.

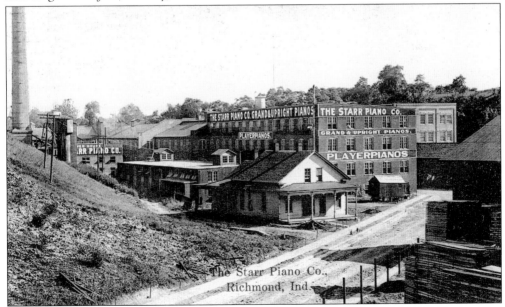

STARR PIANO COMPANY. This view looks south from First Street. (Courtesy of Gary Batchelor.)

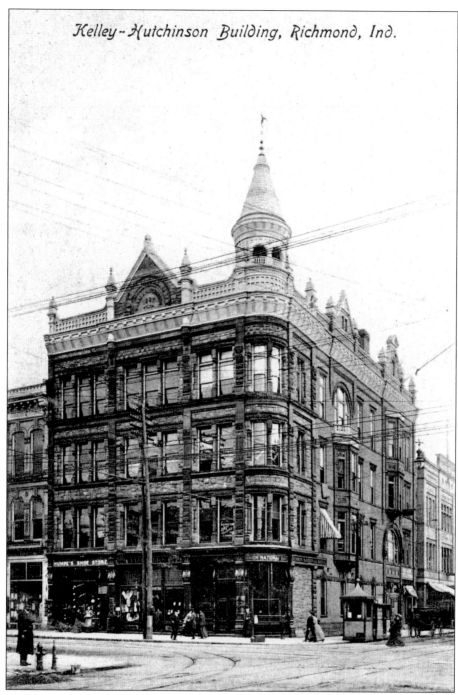

Kelley-Hutchinson Building, Richmond, Ind.

KELLY-HUTCHINSON BUILDING. Built in 1887 by LeRoy Kelly and Judge E. B. Hutchinson, this distinctive building occupied the southeast corner of Eighth and Main Streets, nestled between the Knollenberg Building and its Annex to the south. Architect John Hasecoster designed the structure and located his office on the second floor. The establishment on the first floor at the corner was the Union National Bank. The building was razed in 1933 to make way for a Kresge store.

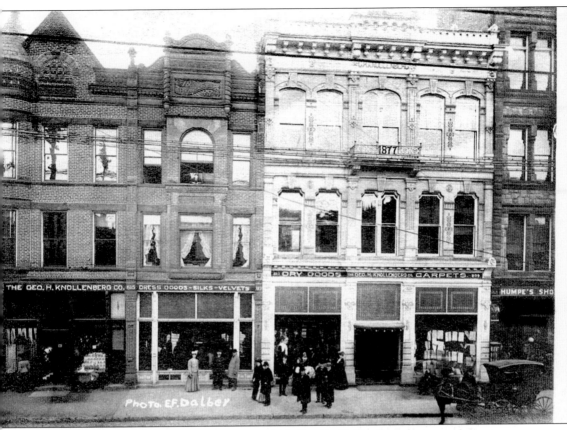

George H. Knollenberg Company. In 1866, George H. Knollenberg opened a one-room retail dry goods store in a small frame building on Main Street. It was successful enough that, in 1877, he built the three-story building seen to the right in this postcard, followed by the rest of the pictured building in 1888. In 1896, he built the Annex, another three-story structure adjoining these to the rear and facing Eighth Street. Knollenberg's Department Store was a Richmond institution until the 1990s, when competition from large chain stores drove it out of business. It closed in 1995. (Courtesy of Gary Batchelor.)

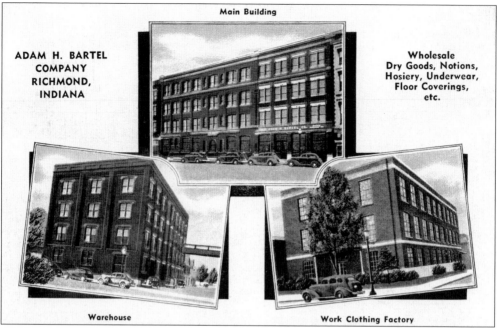

ADAM H. BARTEL COMPANY. This company began in 1877, when Adam Bartel founded his wholesale business. Located at North E Street between Ninth and Tenth, the main building was constructed in 1891. The warehouse, standing just south of the main building, has since been renovated into artists' studios and a coffee bar. The Bartel Company also produced a line of work clothing called the Perfection Brand. This was manufactured in the factory at South Eighth and B Streets, now a senior apartment facility. (Courtesy of the Wayne County Historical Museum.)

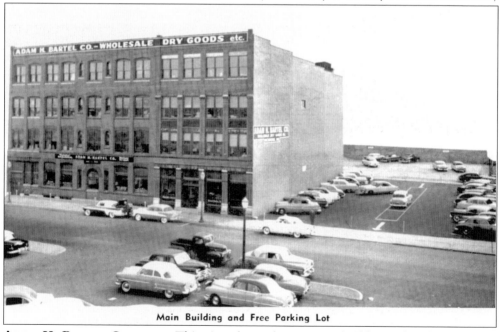

ADAM H. BARTEL COMPANY. This view shows the company buildings after the Arlington Hotel was torn down in 1956 (see page 24). (Courtesy of Gary Batchelor.)

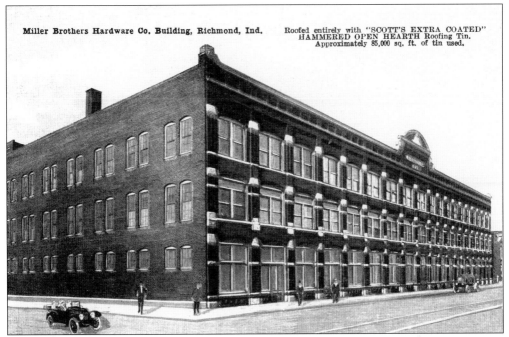

Miller Brothers Hardware Co. Building, Richmond, Ind. Roofed entirely with "SCOTT'S EXTRA COATED" HAMMERED OPEN HEARTH Roofing Tin. Approximately 85,000 sq. ft. of tin used.

MILLER BROTHERS. The wholesale hardware firm of Pogue, Miller, and Company moved to this site on Fort Wayne Avenue in 1890. In 1911, George Miller and his brothers Frederick and Jacob reorganized the company under the name Miller Brothers. The business and its buildings expanded over the years until, in 1911, it could claim to be the fifth largest hardware company in the country. The company occupied this building until 1971 and went out of business in 1973. The building has been renovated into a furniture store. (Above courtesy of the Wayne County Historical Museum; below courtesy of Gary Batchelor.)

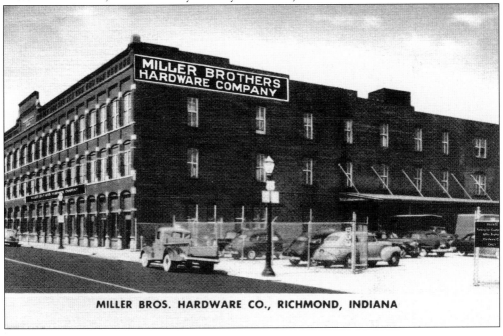

MILLER BROS. HARDWARE CO., RICHMOND, INDIANA

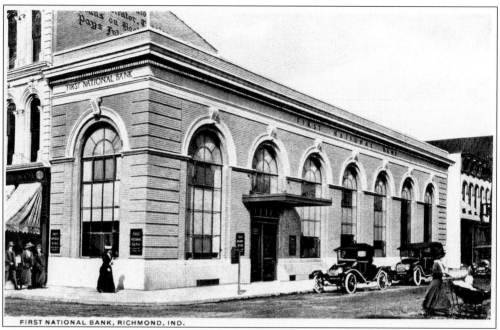

FIRST NATIONAL BANK, RICHMOND, IND.

FIRST NATIONAL BANK. This bank received United States Charter No. 17 on June 30, 1863. The above card pictures the bank's third building at the same location at Seventh and Main Streets. This space was opened in 1915 and further renovated in 1923, 1959, and 1972–1974. (Courtesy of Gary Batchelor.)

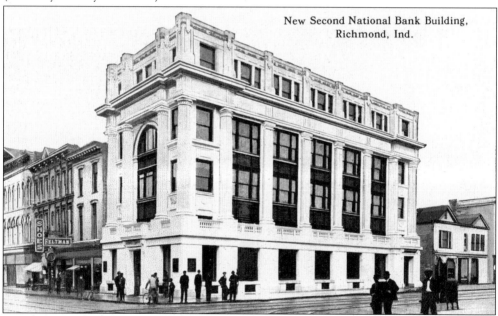

New Second National Bank Building, Richmond, Ind.

SECOND NATIONAL BANK. The Second National Bank was chartered on May 28, 1872. This building, standing on the northwest corner of Eighth and Main Streets, was constructed in 1910–1911. In 1956, it expanded and moved into the space across the street that had been occupied by Dickinson Trust, and in 1958, the Peoples Home and Savings Association moved into this building.

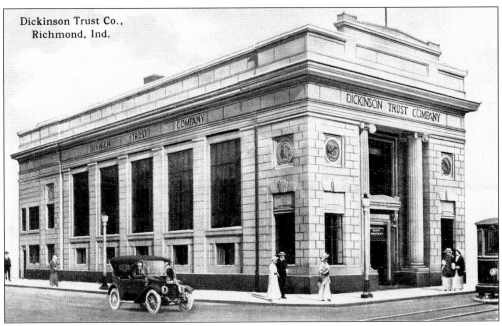

Dickinson Trust Co.,
Richmond, Ind.

DICKINSON TRUST COMPANY. J. Dickinson and Company incorporated as the Dickinson Trust Company in 1899, constructing this building on the northeast corner of Eighth and Main Streets in 1916. A view of the interior is pictured below. The company's commercial business did not survive the Depression, but it remained a trust institution until 1945, when it was liquidated. In 1956, the Second National Bank renovated the building and moved its operations from across the street.

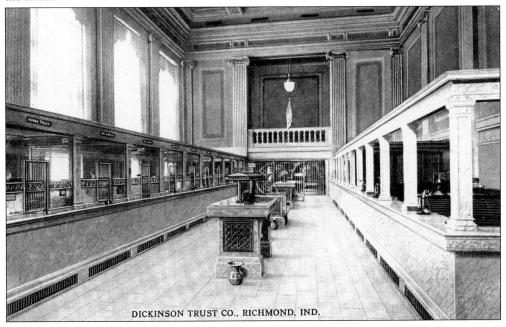

DICKINSON TRUST CO., RICHMOND, IND.

FALL FESTIVALS. Initiated by the Young Men's Business Club, the Fall Festival was a short-lived enterprise designed to promote and advertise Richmond. Held in October, the festivals included parades, livestock exhibits, machinery displays, concerts, and contests. The 1908 Festival was scheduled to coincide with a visit of the U.S. Army's 10th Division, so this year also included a Military Day.

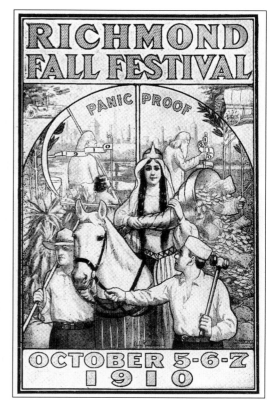

WAYNE COUNTY CENTENNIAL. The 1910 Festival also celebrated Wayne County's centennial and featured Richmond's newest promotional name, "the Panic Proof City," referring to its seeming freedom from the effects of several economic depressions, or panics.

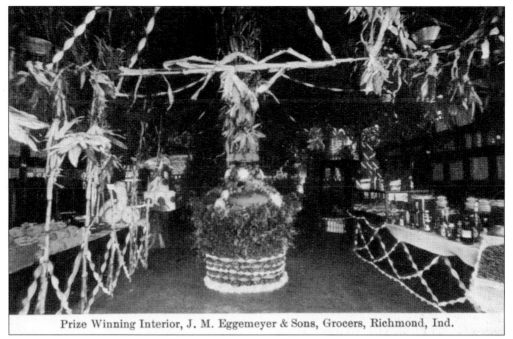

Prize Winning Interior, J. M. Eggemeyer & Sons, Grocers, Richmond, Ind.

FALL FESTIVALS. Everything in town was decorated—from city hall to office interiors to parade floats. Prizes and prestige were at stake, so many businesses spared no expense to promote themselves, which was the whole point of the festival. Pictured above is a view of the decorated interior of the J. M. Eggemeyer and Sons Grocery store. It won first prize in the competition for decorated shops. A. Stolle and Sons' parade float, pictured below, won first prize in the parade float competition.

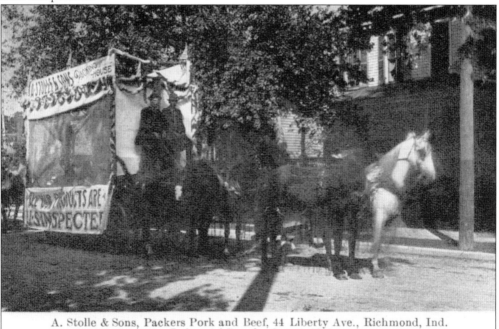

A. Stolle & Sons, Packers Pork and Beef, 44 Liberty Ave., Richmond, Ind.
FIRST PRIZE—Industrial Parade, Oct. 7, 1909—FIRST PRIZE

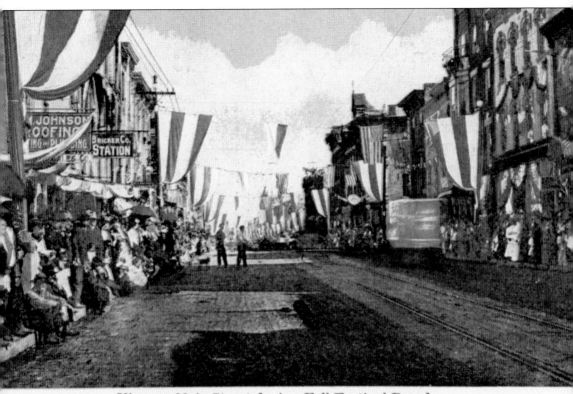

View on Main Street during Fall Festival Parade.

FALL FESTIVAL PARADE. No festival occurred in 1911 or 1912. In 1912, the Young Men's Business Club merged with the Commercial Club and decided to try the Fall Festival again. The 1913 festival, as well as the first three, were well attended but not terribly profitable, and afterward, the club decided to use its funds and efforts in other more effective advertising projects. The festival was discontinued.

Five

CHURCHES

Religion has always played an important part in Richmond's history. Most of the first arrivals were Quakers, and members of the Society of Friends were influential in Richmond's civic, cultural, and industrial development. Within a few years, the Quakers were joined by Methodists, Presbyterians, Catholics, Episcopalians, and Lutherans, with many others to follow in later years. Many of these religious groups, in turn, founded hospitals, orphanages, and schools. Their houses of worship are some of the most notable buildings in town.

The church pictured below, located at the northwest corner of North A and Fifth Streets, was built from 1851 to 1853 and was occupied by several denominations, beginning with the Pearl Street Methodist Episcopal congregation until 1883. From 1893 to 1914, it again became a Methodist church, this time known as the Fifth Street Methodist Episcopal Church. From 1916 to 1966, it was a Nazarene church, after which it became an interdenominational parish. It was razed in 1971 to allow for the current post office.

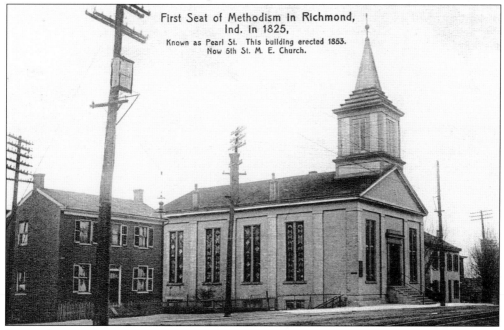

PEARL STREET METHODIST EPISCOPAL CHURCH.

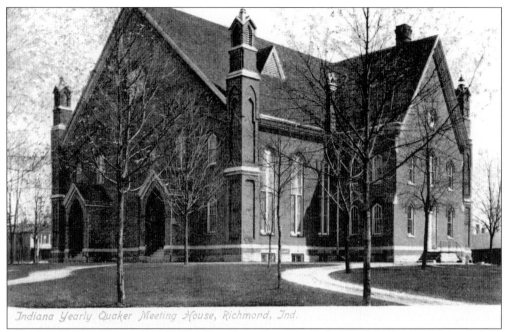

Indiana Yearly Quaker Meeting House, Richmond, Ind.

INDIANA YEARLY MEETING HOUSE. This building, located on East Main between Fifteenth and Sixteenth Streets, was constructed for the newly formed East Main Street Friends Meeting in 1878. It was extensively renovated in 1912 to the appearance seen below. In 1997, it was torn down to make way for a CVS pharmacy.

GRACE METHODIST EPISCOPAL CHURCH.
Members who withdrew from the Pearl
Street church in 1858 erected this church
on the southwest corner of North A and
Tenth Streets in 1868. When they moved
into the new church in January 1869, they
named it Grace Methodist Episcopal. It was
extensively renovated in 1918, becoming the
Central Methodist Church, pictured below.
The structure was razed in 1958, after the
congregation had moved to its new home at
Main and Fifteenth Streets.

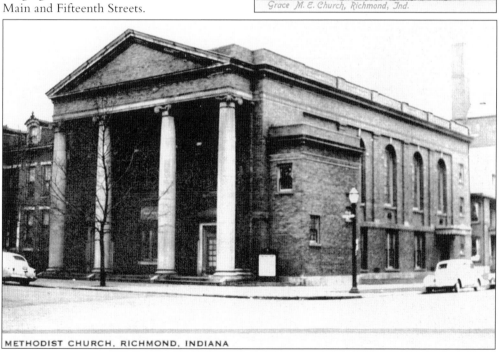

Grace M. E. Church, Richmond, Ind.

METHODIST CHURCH, RICHMOND, INDIANA

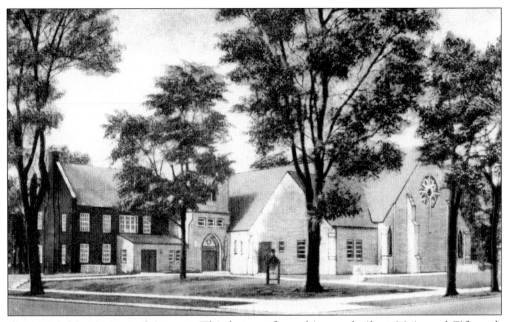

CENTRAL METHODIST CHURCH. This house of worship was built at Main and Fifteenth Streets in 1957.

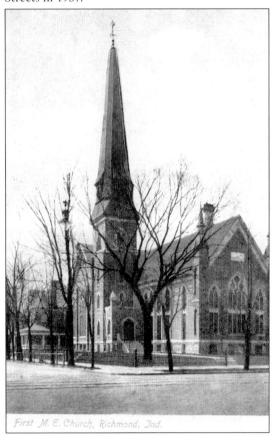

First M. E. Church, Richmond, Ind.

FIRST METHODIST EPISCOPAL CHURCH. The congregation occupying the Pearl Street church built this new structure on the southwest corner of Main and Fourteenth Streets in 1884. In 1926, the congregation merged with that of the Grace Methodist Episcopal Church, and this building was torn down in 1935.

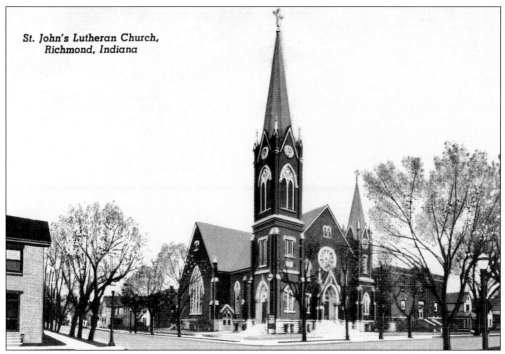

*St. John's Lutheran Church,
Richmond, Indiana*

ST. JOHN'S LUTHERAN CHURCH. The first Lutheran congregation was organized in 1844 and built its first church at 320 South Fourth Street, a structure that remains today. In 1907, the congregation built the church pictured here, which still occupies the southeast corner of South E and Seventh Streets.

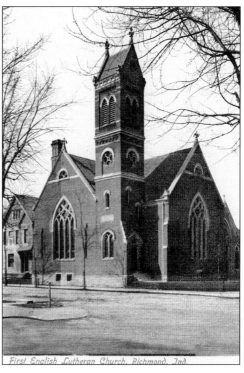

FIRST ENGLISH LUTHERAN CHURCH. Organized in 1884, the congregation constructed this building on the southwest corner of South A and Eleventh Streets in 1885. Members remained there until 1960, when a new structure was built at 2727 East Main Street. Soon after the move, this church was torn down.

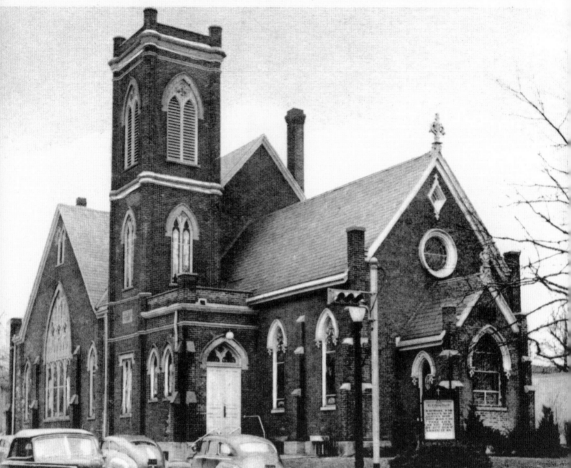

TRINITY LUTHERAN CHURCH. In 1869, this building was constructed on the southeast corner of South A and Seventh Streets by the Swedenborgian Society, which disbanded sometime in the 1880s. In 1892, a group of Lutherans withdrew from St. John's and formed Trinity Lutheran Church. They bought this building and, in 1907, made a major addition to it. In 1958, the congregation bought land at 2300 West Main Street and built its present church, dedicating it in 1963, after which this building was demolished.

ST. PAUL'S LUTHERAN CHURCH, 1857.
This church was organized by a group that
withdrew from St. John's in 1852. Located on
the east side of South Seventh Street between
C and E Streets, it was completed in 1857, with
later additions including an 1892 chapel and a
parsonage. The congregation worshipped here
until 1952. This church is currently home to
the Victory Pentecostal Tabernacle.

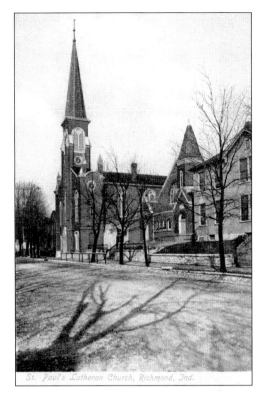

St. Paul's Lutheran Church, Richmond, Ind.

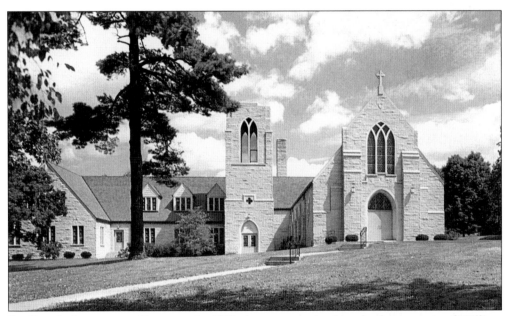

ST. PAUL'S LUTHERAN CHURCH. In 1939, the congregation bought the property of William
Dudley Foulke, nationally famous lawyer and reformer, at South A and Eighteenth Streets.
The home was razed, and in its place this new church was built and dedicated in 1952. The
congregation still occupies it.

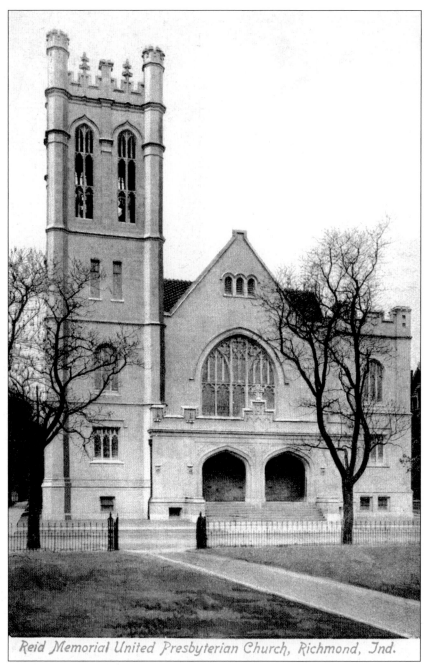

Reid Memorial United Presbyterian Church, Richmond, Ind.

REID MEMORIAL UNITED PRESBYTERIAN CHURCH. The United Presbyterian congregation built its first church in 1858 on South Fifth Street and the second in 1871 on the northwest corner of North B and Eleventh Streets—a building that still exists. In 1906, members moved into their present church on the northwest corner of North A and Eleventh Streets, a structure financed entirely by Daniel G. Reid to memorialize his parents. Reid spared no expense in the construction. The church cost more than a $250,000 and was dedicated on May 13, 1906. Scottish Gothic in design, it was built with Bedford stone laced with intricate carving. Its massive bell tower includes chimes consisting of 10 bells.

TIFFANY WINDOW. The Reid Memorial United Presbyterian Church interior was designed by Tiffany Studios of New York City and naturally displays many Tiffany windows like the one seen here.

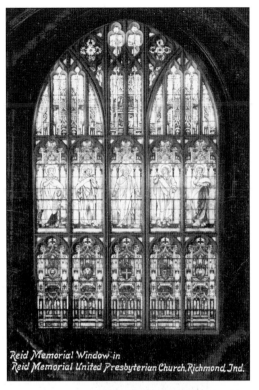

Reid Memorial Window in Reid Memorial United Presbyterian Church, Richmond, Ind.

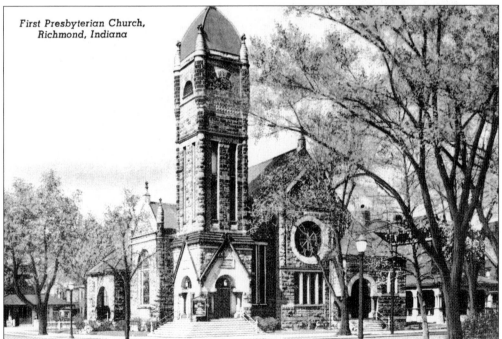

First Presbyterian Church, Richmond, Indiana

FIRST PRESBYTERIAN CHURCH. This congregation was organized in 1837 and built its first church on South Fourth Street and its second on South Eighth Street. In 1886, members built the above church on the northeast corner of North A and Tenth Streets and still worship there today.

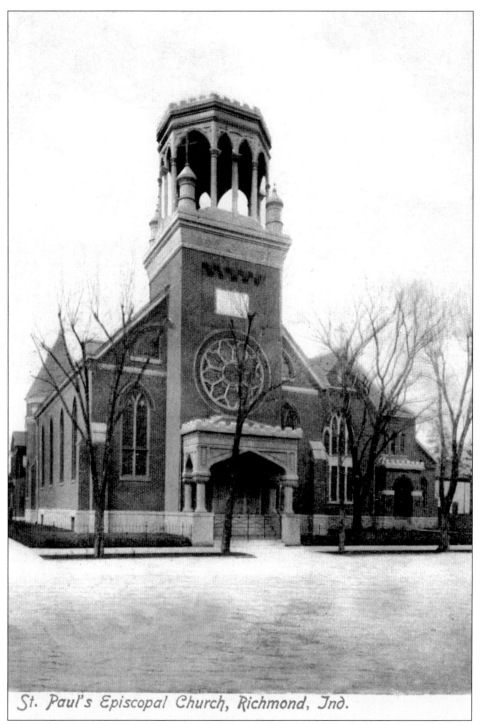

St. Paul's Episcopal Church, Richmond, Ind.

ST. PAUL'S PROTESTANT EPISCOPAL CHURCH. One of the oldest existing structures in the city, this church was constructed from 1840 to 1849. The basement, ready in 1841, was initially used for services. In 1892, the building was enlarged and a chapel constructed. The parsonage to the east was also built in 1892. A Tiffany window was added in 1903.

ST. ANDREW'S CATHOLIC CHURCH. The first Catholic organization in Richmond was formed in 1846 by German immigrants. The first substantial church was built in 1860 on the northeast corner of South C and Fifth Streets. This building burned in 1900, but a new one, seen here, was quickly built on the ruins of the first. The spire rises 186 feet above Fifth Street and contains a clock and bells that are neighborhood institutions. The schoolhouse, shown in this view to the south (right), was built in 1864.

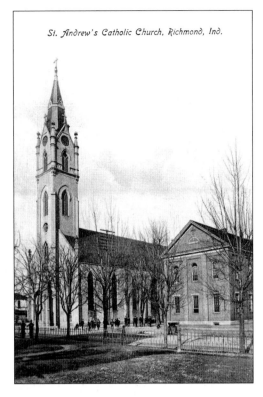

St. Andrew's Catholic Church, Richmond, Ind.

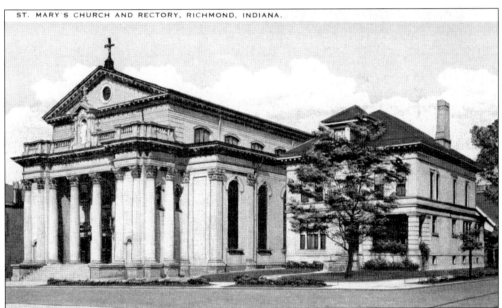

ST. MARY'S CHURCH AND RECTORY, RICHMOND, INDIANA.

ST. MARY'S CATHOLIC CHURCH. Members of this congregation withdrew from St. Andrew's to establish an English-speaking church and bought a former Lutheran church on the corner of North A and Seventh Streets. In 1909, the congregation decided to build a new church and parish house. The parish house, located at the corner of North A and Eighth Streets, was completed quickly, but the large church just to the west was not completed until 1913.

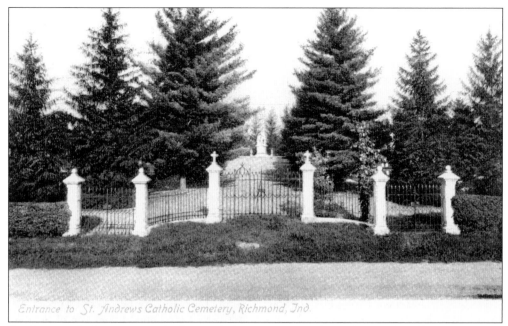

ST. ANDREW'S CEMETERY. The first Catholic cemetery was located at South Fifth and G Streets, but the city quickly grew to surround that plot. In 1866, St. Andrew's purchased 10 acres for a new cemetery about one mile south of the church on Liberty Pike.

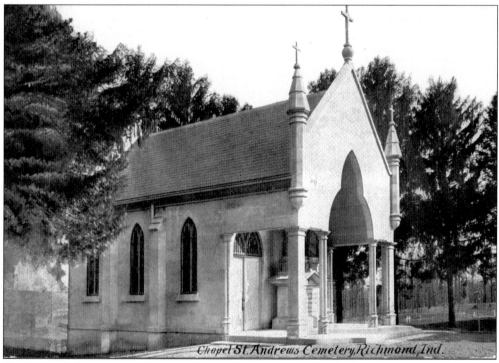

ST. JOSEPH'S MORTUARY CHAPEL. Erected in the center of St. Andrew's Cemetery, this chapel was dedicated on November 1, 1908.

Six

EDUCATION

The Quaker influence in Richmond's educational history is very strong. The earliest schools that existed in the area were started by the Friends, and the Quakers have been active in education ever since. Most noticeable today is the institution that opened on the west side of the river as the Friends Boarding School in 1847 and grew into Earlham College, a nationally known liberal arts college.

In the early 20th century, Richmond was recognized as a center of arts and music, due at least partially to Richmond's high schools and their relationship to the Richmond Art Association, which had been founded in 1898. The secondary school buildings constructed in 1909–1910 and 1939–1941 both contained theaters, auditoriums, and art galleries. Richmond was one of the first schools in the country to have a high school orchestra and remains the only school in which the city's art museum is located within its walls.

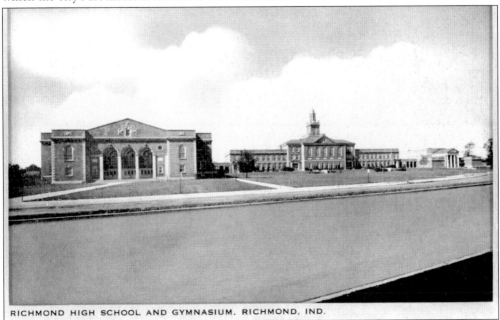

RICHMOND HIGH SCHOOL AND GYMNASIUM. RICHMOND, IND.

RICHMOND HIGH SCHOOL COMPLEX.

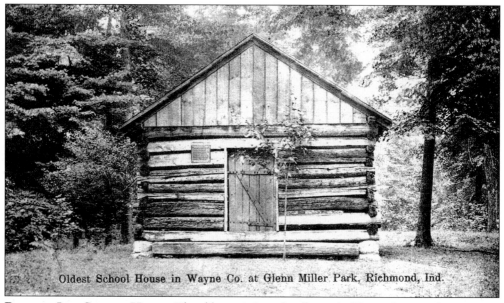

Oldest School House in Wayne Co. at Glenn Miller Park, Richmond, Ind.

ROBERTS LOG SCHOOL HOUSE. The oldest existing schoolhouse in Wayne County, this structure was erected on the Roberts farm for the Hawkins family in 1812 and was used as a school the following year. In 1903, Albert Reed bought the cabin, moved it to Glen Miller Park, and dedicated it to his father, Irvin Reed, and other early advocates of public schools. It is now located on the grounds of the Wayne County Historical Museum. (Courtesy of Gary Batchelor.)

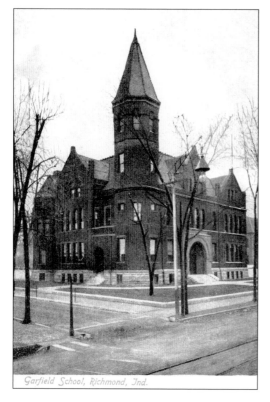

Garfield School, Richmond, Ind.

GARFIELD SCHOOL. This school was built at North Eighth and B Streets in 1895. In 1909, it became the west annex of the Morton High School, and the Garfield name was transferred to the building on South Twelfth Street. This building was destroyed in a spectacular fire in March 1924. The stone arch seen to the right is now located in Hayes Arboretum.

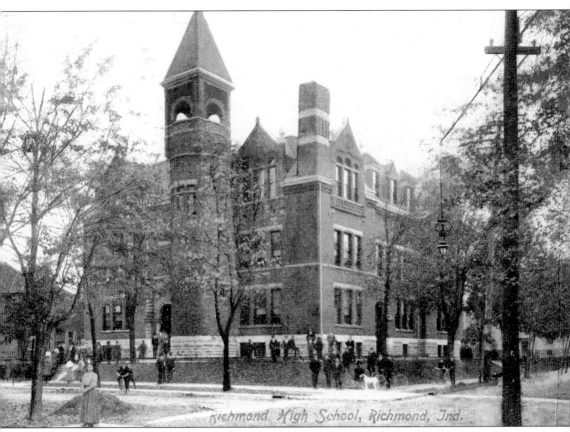

RICHMOND HIGH SCHOOL. The second building to house Richmond High School, this building was constructed in 1888. When the new high school opened in 1910, this school became the junior high school and gained the name of Garfield. This structure was a junior high school until 1922, when Julia Test Junior High opened. It then became an elementary school until Charles Elementary opened in 1954. The building was razed in 1956, and the corner is now the site of the Eagles Lodge.

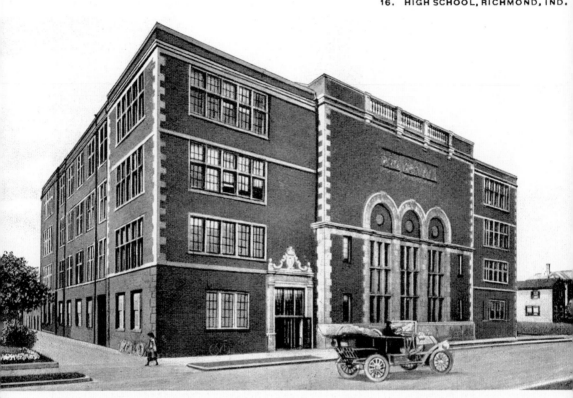

MORTON HIGH SCHOOL. Richmond's population quickly outgrew the high school at Twelfth Street, and in 1909–1910, the city built a new school at North Ninth and B Streets. This new high school included an art gallery on the third floor that housed and displayed the collection of the Richmond Art Association. This unique relationship continued when the present school complex was built in the 1930s. In addition to art education, vocational education was emerging during this time. Above the three arches on the façade are nine ceramic tile reliefs depicting various occupations, such as printer, stonecutter, and blacksmith, which represent the belief in teaching the manual arts in addition to purely academic subjects. The building was renamed Morton High School in 1921, and since 1952, it has served as offices for an insurance company.

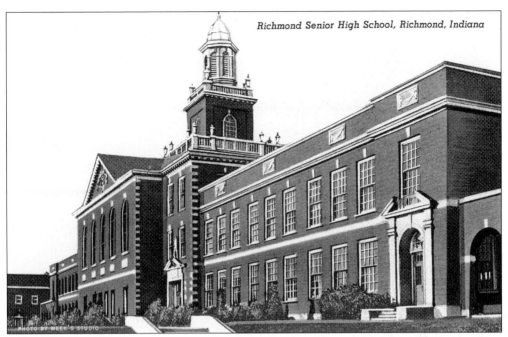

Richmond Senior High School, Richmond, Indiana

RICHMOND SENIOR HIGH SCHOOL. The first building of the current high school was a New Deal project, partially funded by the Public Works Administration. It has been added to many times over the years to keep up with trends in education.

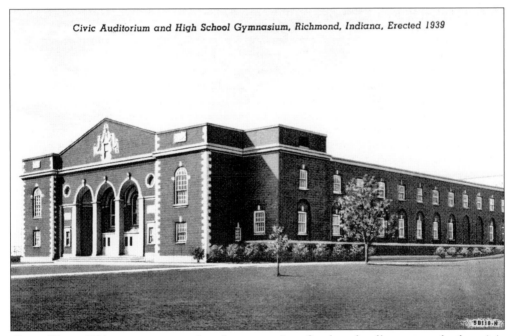

Civic Auditorium and High School Gymnasium, Richmond, Indiana, Erected 1939

CIVIC HALL. This structure served as the gymnasium for the school's sports and other civic functions, but in 1984, when the Tiernan Center became the new sports center, an effort was launched to make this a state-of-the-art performance venue. After undergoing an extensive renovation, the new Civic Hall Performing Arts Center opened in 1993.

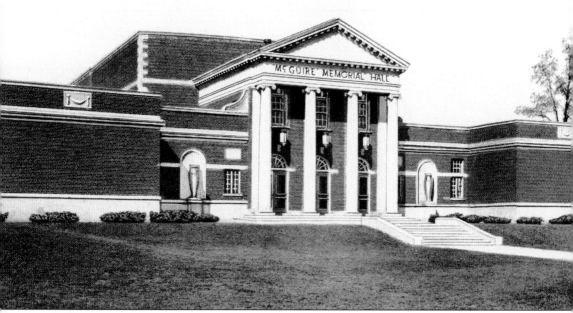

MCGUIRE MEMORIAL HALL. The north wing of the school complex was to be the vocational and fine arts building, and it was the last to be funded. In January 1939, lawn mower manufacturer Charles A. McGuire donated $25,000 to the project to memorialize his mother, and when it looked as though delays in the federal grants would curtail construction, he donated another $25,000. In addition to classrooms, this building contains a small theater and an art gallery in which the collection of the Richmond Art Association is housed and displayed.

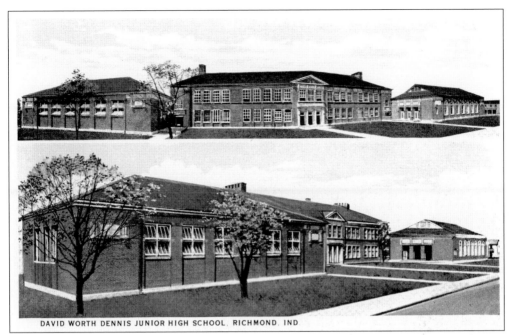

DAVID WORTH DENNIS JUNIOR HIGH SCHOOL, RICHMOND, IND.

DAVID WORTH DENNIS JUNIOR HIGH SCHOOL. One of the first junior high schools in the country, this school, located on Northwest Seventh Street, was dedicated in April 1922. It was named for the longtime Earlham College biology professor who had also taught in the Richmond school system for a short time.

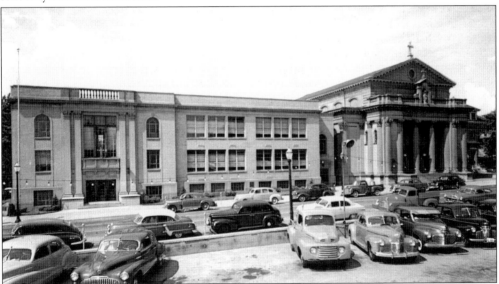

ST. MARY'S SCHOOL. Lutheran and Catholic churches have conducted their own schools in Richmond since the mid-1800s. Located on the northeast corner of North A and Seventh Streets, St. Mary's School was dedicated in 1939 to replace the previous school that was located across the street on the southeast corner, where these cars are parked. The school is now the East Campus of the Seton Elementary School. Just visible to the left is the stone monument to Henry Clay's 1842 visit to Wayne County and his confrontation with Hiram Mendenhall, which occurred not far from this location.

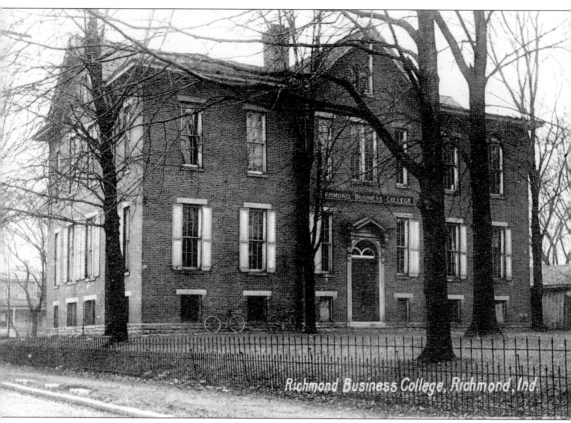

RICHMOND BUSINESS COLLEGE. In 1868, this building was constructed as the Hicksite Friends' school on North B Street, between Eleventh and Twelfth Streets and just north of the meetinghouse. In 1891, the Hicksites rented it to the Richmond Business College, and the college remained there until 1911, when it moved downtown to the Colonial Building at Main and Seventh Streets. In 1915, the building was torn down and replaced by a 30-unit apartment building called the Wilmore, intended for single working women. (Courtesy of Gary Batchelor.)

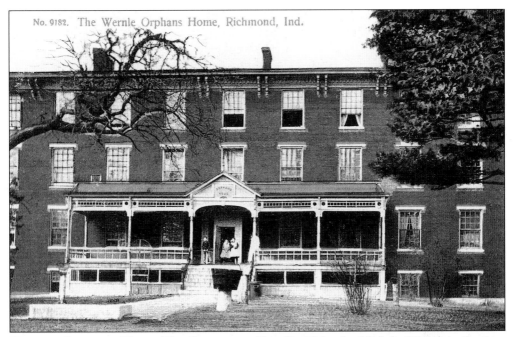

No. 9182. The Wernle Orphans Home, Richmond, Ind.

WERNLE OPRHANS HOME. The Greenmount Boarding School, a Hicksite Friends institution, opened southeast of Richmond in 1852. The school was not successful, and from 1858 to 1878, the facility served as a sanitarium. In 1878, the Joint Lutheran Synod at Wheeling, West Virginia, voted to buy the building and grounds and to start an orphans' home. The postcard above shows the original main building before it was rebuilt and rededicated in 1910, and the one below reveals the post-1910 version.

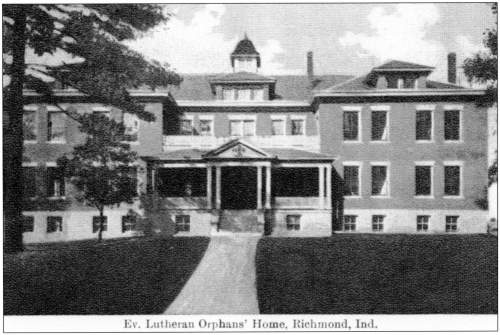

Ev. Lutheran Orphans' Home, Richmond, Ind.

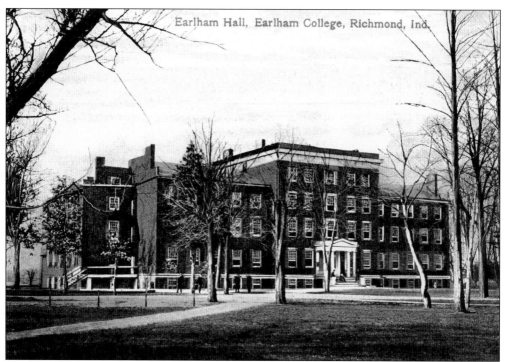

Earlham Hall, Earlham College, Richmond, Ind.

EARLHAM HALL. The first—and for a long time the only—building of the Friends Boarding School, Earlham Hall was constructed from 1839 to 1855, as funding allowed. After 1887, when Lindley Hall was built, Earlham Hall became a dormitory. By the 1950s, maintenance and renovation was proving too costly, and it was torn down and replaced by a new Earlham Hall on nearly the same spot and with a very similar appearance, as seen below.

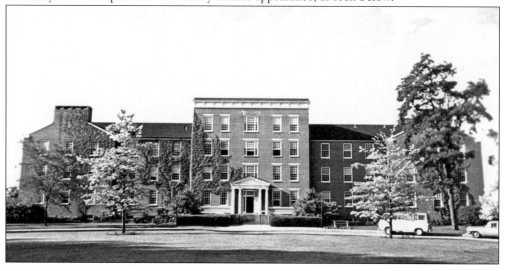

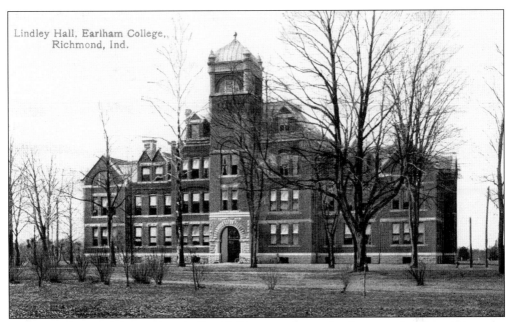

LINDLEY HALL. Built in 1887, Lindley Hall became the academic center, housing classrooms, offices, and the museum, allowing Earlham Hall to become exclusively a dormitory. Lindley Hall was destroyed on October 23, 1924, in an arson blaze that killed a Richmond firefighter.

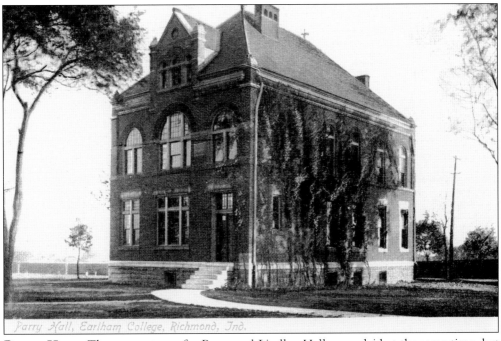

PARRY HALL. The cornerstones for Parry and Lindley Halls were laid at the same time, but Parry Hall, being smaller, was ready for use a few months sooner. It was a science facility, with a lecture hall and chemistry and physics laboratories. It was razed in 1954 to make way for Barrett Hall dormitory.

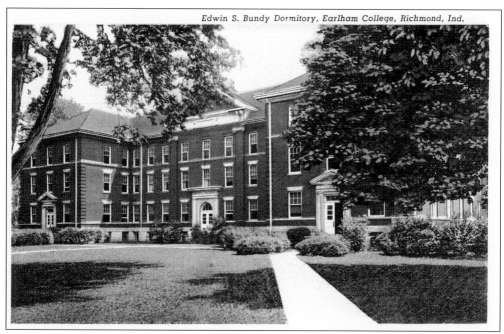

Edwin S. Bundy Dormitory, Earlham College, Richmond, Ind.

BUNDY HALL. Opened in 1907 as the second dormitory on campus, Bundy Hall accommodated the male students, while the female students remained in Earlham Hall.

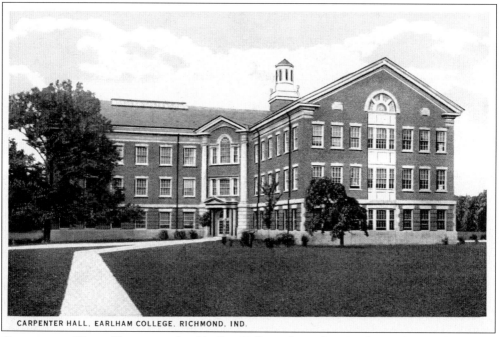

CARPENTER HALL, EARLHAM COLLEGE, RICHMOND, IND.

CARPENTER HALL. Very soon after Lindley Hall was lost, planning began for a replacement. The cornerstone for Carpenter Hall was laid in 1927, and construction was finished by the fall of 1929.

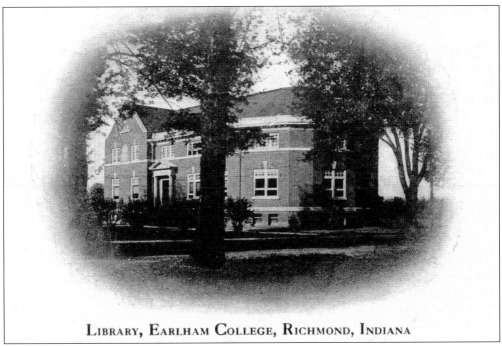

LIBRARY, EARLHAM COLLEGE, RICHMOND, INDIANA

LIBRARIES. The first building designed solely to be a library was opened in 1907. Its major donor was Andrew Carnegie, whose foundation financed mostly public libraries during this era. The donation of $30,000 was made with the provision that Earlham raise the same amount for an endowment. The above building remained the library until 1963, when the current Lilly Library, shown below, was opened. The Carnegie Library was remodeled into a classroom building and renamed Tyler Hall. (Courtesy of the Earlham College Archives.)

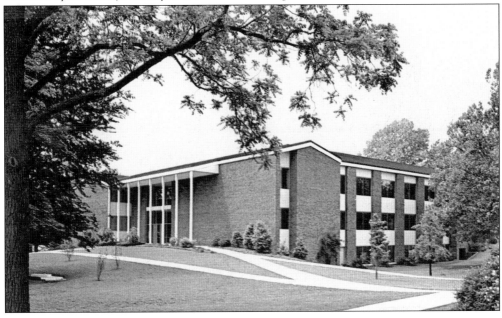

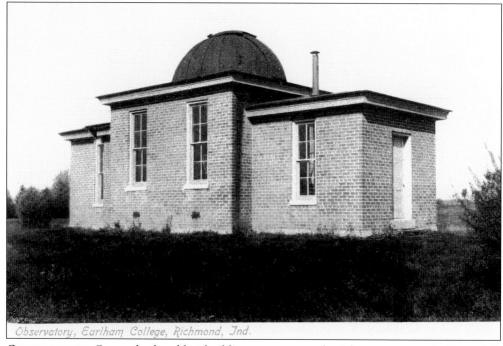

Observatory, Earlham College, Richmond, Ind.

OBSERVATORY. Currently the oldest building on campus, the Observatory was built in 1861 to house the large telescope that the college had acquired in 1856. It was continuously in use from 1861 to 1973, even though the construction of Carpenter Hall in 1929 blocked much of its view of the southern sky.

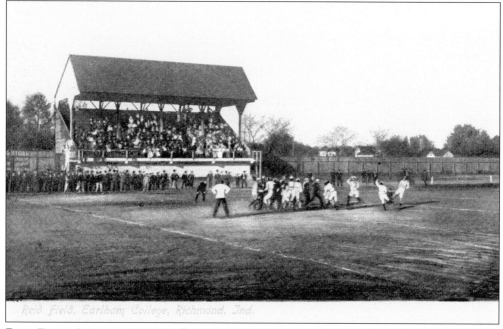

Reid Field, Earlham College, Richmond, Ind.

REID FIELD. In January 1900, Earlham announced that it would consolidate all athletic activities on a new field. By April, $2,000 of the $2,500 needed for the project had been collected, including $500 from Daniel G. Reid, for whom the field was then named.

Seven

PARKS AND RECREATION

As the city grew, it was important to provide green spaces for escape from city living and areas for sports and other recreation. Richmond's city government has always been attentive to this need, and its citizens have enjoyed a variety of parks over the years. Springs and rivers have afforded opportunities for swimming and boating, and wooded areas for walking. Athletic parks, baseball diamonds, golf courses, and other sports venues have existed throughout Richmond's history.

Culturally, Richmond residents have been well supplied with opportunities for art, entertainment, and education of all varieties. Being a railroad center ensured that Richmond's many theaters would have access to some of the best traveling acts in the country, and when moving pictures arrived, some of the theaters converted to movie houses. Residents also enjoyed a large annual Chautauqua gathering for about 20 years.

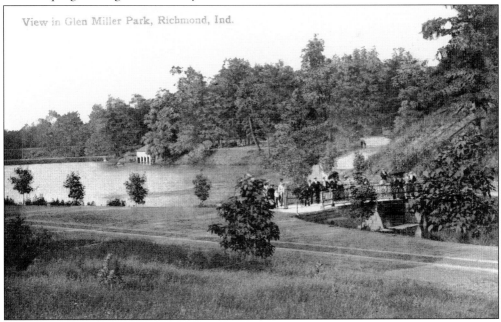

View in Glen Miller Park, Richmond, Ind.

VIEW OF THE LAKE AT GLEN MILLER PARK.

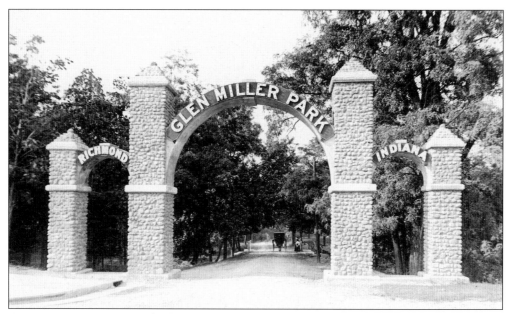

GLEN MILLER PARK. Nearly all newcomers to Richmond initially assume that the city's largest park is named for the big band leader of the 1930s and 1940s, which is not the case. Glen Miller Park takes its name from Col. John F. Miller, who bought the property in 1880 from Nathaniel Hawkins knowing that it would make a good park. Colonel Miller, an executive with the Pennsylvania Railroad, personally financed some of the early development of the future park. In 1885, the city purchased the park from Colonel Miller and continued improvements.

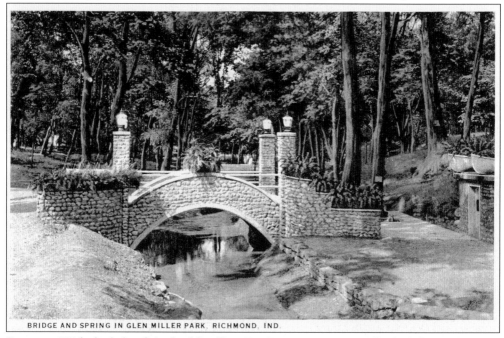

BRIDGE AND SPRING IN GLEN MILLER PARK, RICHMOND, IND.

SPRINGS. With the help of city health officer Dr. T. Henry Davis, Miller had the spring water tested, and the analysis showed high quantities of iron, which added to the health benefits of the drinking water. The spring shown above is still in use today.

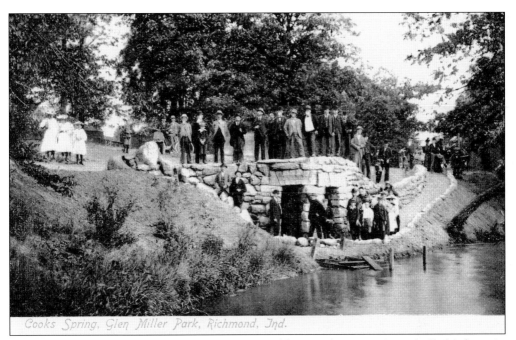

Cooks Spring, Glen Miller Park, Richmond, Ind.

COOK'S SPRING. The spring in this area was inaccessible, so park commissioners built this fountain and surrounding grotto. The source of the funds was kept secret until just before the dedication on June 13, 1896, when the donor was revealed to be county treasurer William P. Cook.

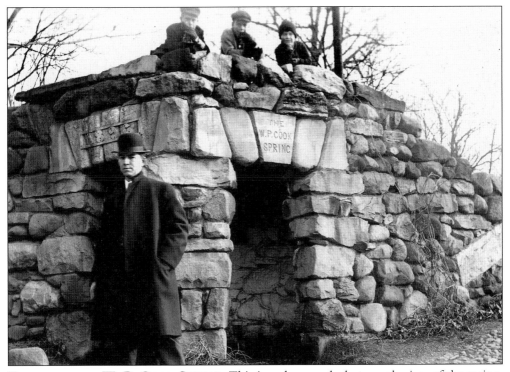

DETAIL OF THE W. P. COOK SPRING. This is a closer real-photograph view of the spring. (Courtesy of Gary Batchelor.)

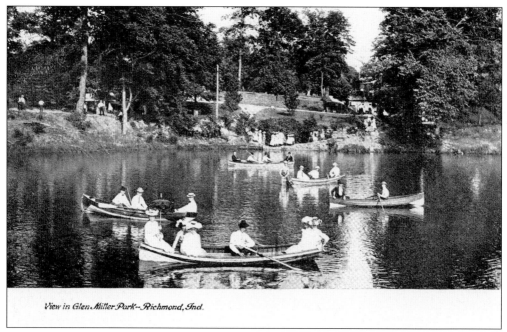

View in Glen Miller Park--Richmond, Ind.

CANOEING ON THE LAKE. Once home to a mill, the lake later became one of the most popular and picturesque spots in the park.

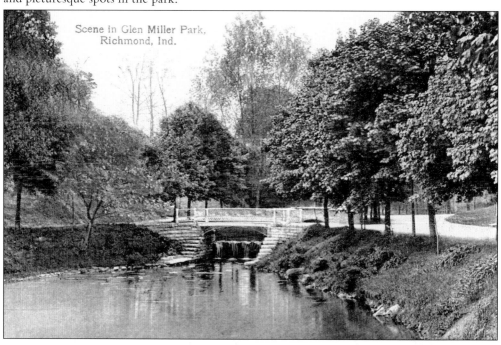

Scene in Glen Miller Park,
Richmond, Ind.

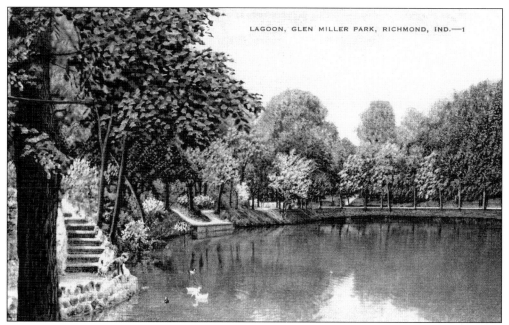

FEEDING THE DUCKS. Children feed the animals from the Cook's Spring grotto steps.

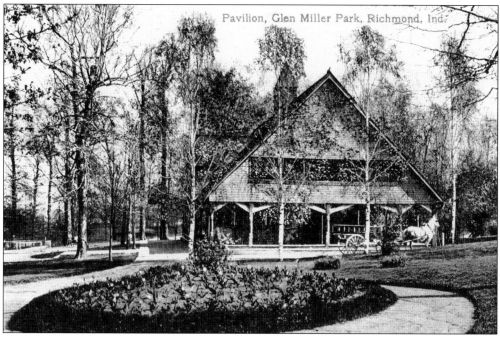

PAVILION. The pavilion was situated near the location of the current administration building. When it was torn down in the early 1960s, its lumber was used to build Shelter House No. 1.

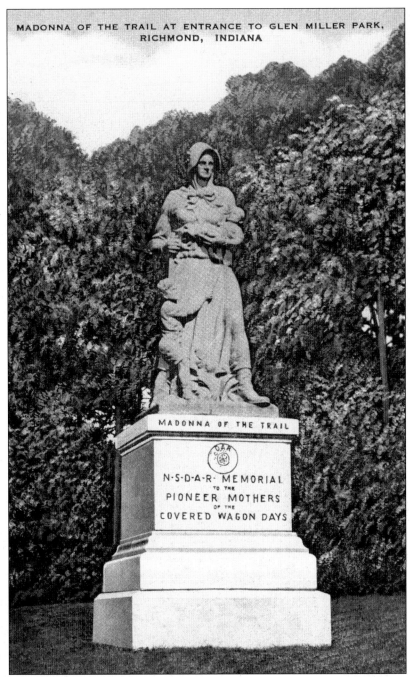

MADONNA OF THE TRAIL AT ENTRANCE TO GLEN MILLER PARK, RICHMOND, INDIANA

MADONNA OF THE TRAIL

D.A.R.

N·S·D·A·R· MEMORIAL
TO THE
PIONEER MOTHERS
OF THE
COVERED WAGON DAYS

MADONNA OF THE TRAIL. In 1887, the city acquired the old Maple Grove Cemetery, which was located north of Main Street between the current Twenty-second and Twenty-third Streets, and made arrangements to have the bodies removed and reburied in Earlham Cemetery. Today, this portion of land is occupied by the Madonna of the Trail memorial. One of a series of monuments along the National Road erected by the Daughters of the American Revolution, it was dedicated on October 28, 1928. Judge Harry S. Truman, at the time the president of the National Old Trails Association, had been to the park earlier and helped choose the site for the memorial.

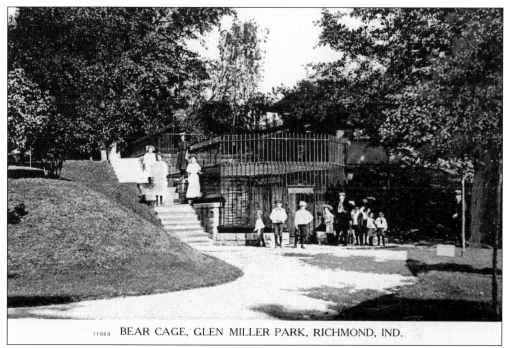

11883 BEAR CAGE, GLEN MILLER PARK, RICHMOND, IND.

PARK ZOO. Soon after Glen Miller opened, park commissioners acquired animals for display. Deer, elk, and a bear were some of the early additions, and over the years the park owned wolves, foxes, alligators, monkeys, and even kangaroos and lions. By the 1980s, it was evident that the city did not have the resources to maintain the zoo, and in August 1986, the last animals were removed from the park.

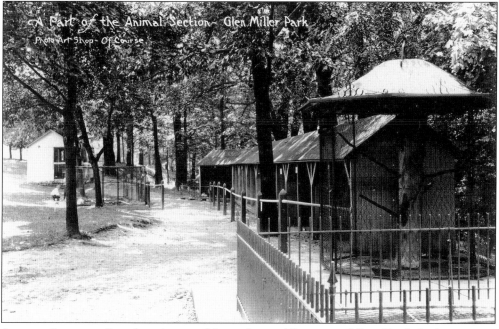

ANIMAL SECTION. Seen here is part of the park zoo. (Courtesy of Gary Batchelor.)

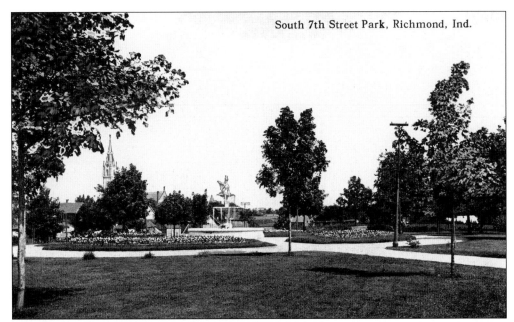

South 7th Street Park, Richmond, Ind.

SOUTH SEVENTH STREET PARK. Another park that began as a cemetery is the one located at South Seventh and E Streets, also known as Swicker Park after the president of the South Side Improvement Association. This organization spearheaded the drive to make the old cemetery a park and collected funds to buy the central fountain. The unidentified gentlemen below are perhaps members of the association on the day of the fountain's dedication, September 4, 1899. In the background is the steeple of St. Andrew's Church.

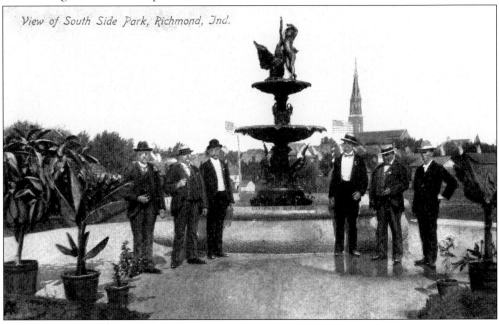

View of South Side Park, Richmond, Ind.

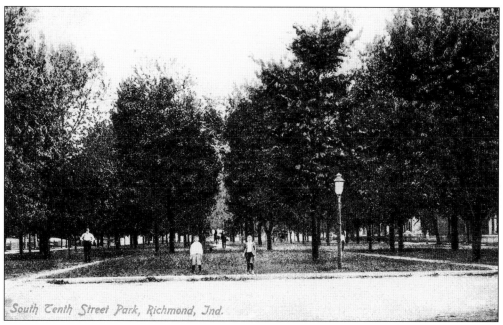

South Tenth Street Park, Richmond, Ind.

SOUTH TENTH STREET PARK. This area was laid out as a park by developers Bickle and Laws in 1853, making it the oldest park in Richmond. Located on South Tenth Street between A and C Streets, it is also the one closest to the downtown area.

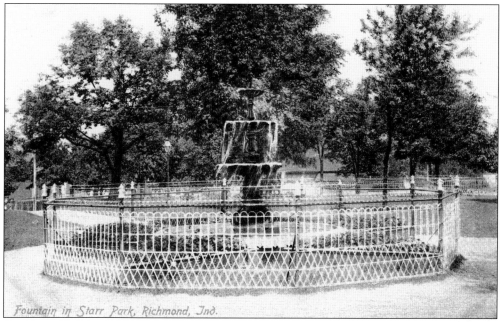

Fountain in Starr Park, Richmond, Ind.

STARR PARK. The area known as Starr Park had once been the Hicksite Friends Burial Grounds. In 1896, James Starr bought the property, had the bodies moved, and created Starr Park in honor of his father, Charles W. Starr. He made all the improvements at his own expense and deeded it to the city free of charge. In the early 1950s, the city took this land for the construction of the Ninth Street overpass. Today, a small memorial is located on the east side of the overpass, commemorating the Hicksite Friends Burial Grounds.

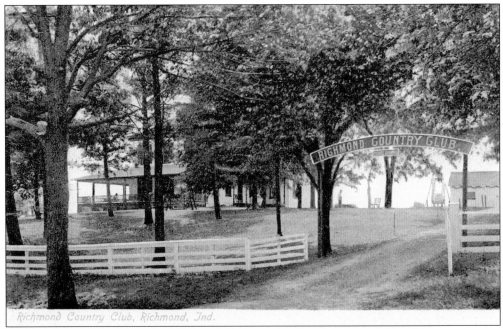

Richmond Country Club, Richmond, Ind.

RICHMOND COUNTRY CLUB. The Richmond Golf Club was the first golf organization in the state, and its first links were laid out southeast of town in 1896. The first country club was established in 1901 on a former farm west of Earlham Cemetery. The clubhouse, seen above, was the renovated farmhouse. This arrangement would last only until 1915, when the clubhouse burned down and Earlham Cemetery wanted the land for expansion. (Courtesy of Monte Muff.)

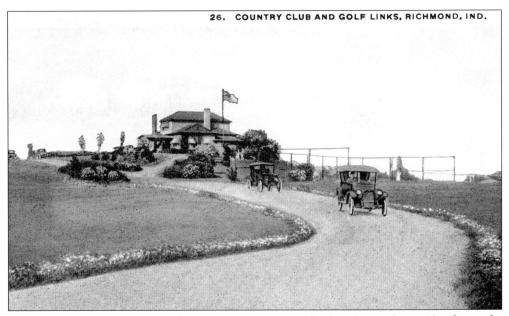

26. COUNTRY CLUB AND GOLF LINKS, RICHMOND, IND.

RICHMOND COUNTRY CLUB. The organization acquired land on the northeast side of town for its new country club. The new clubhouse, built in 1916, would house the golf club until 1927, when the new Forest Hills Country Club was complete. This clubhouse and course were then sold to the Elks Lodge, the owners until moving to a new facility south of town in 1964.

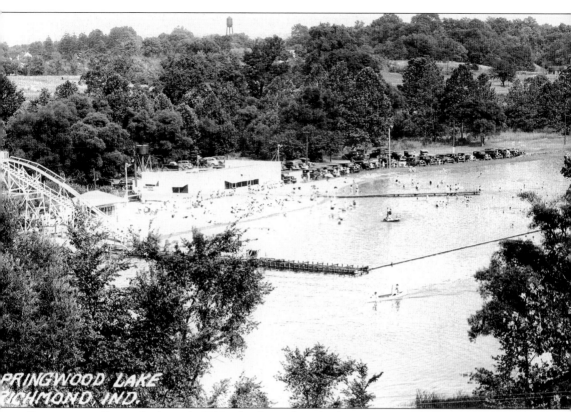

SPRINGWOOD LAKE
RICHMOND, IND.

SPRINGWOOD LAKE. In the early 1930s, developers bought the area just north of Waterfall Road, which at the time was a spring-fed swamp. The lake was created by dredging the swamp, and the developers added a swimming area with a beach, bathhouse, and 30-foot-high slide. Boating, canoeing, and fishing were other attractions, as well as lights that kept crowds there through the summer evenings. In 1944, the Conservation Club bought the park and added skeet shooting and horseback riding. In 1970, the city purchased the park. (Courtesy of Gary Batchelor.)

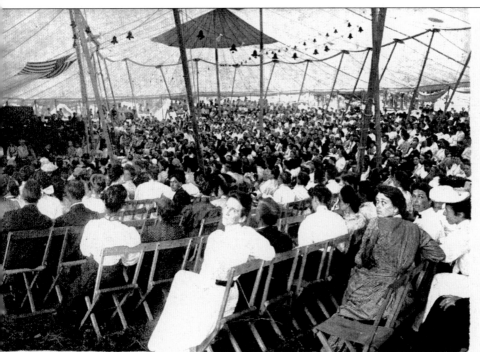

CHAUTAUQUA. Richmond's Chautauqua, a very popular annual event taking place from 1903 to 1923, brought educational and musical programs to local audiences. Some of the more notable headliners included William Jennings Bryan, Booker T. Washington, and Billy Sunday. Glen Miller Park was the site of the temporary tent city, or as it was sometimes called, "the White City," that existed for the duration of the event. More than one 1,000 people camped on the grounds throughout the event. Campers could rent tents and, for an extra fee, a floor for the tent. Dining, electric lighting, spring water, mail delivery, and telephones were just some of the amenities provided by the organizers. Entire families treated Chautauqua as a vacation of sorts. (Courtesy of Gary Batchelor.)

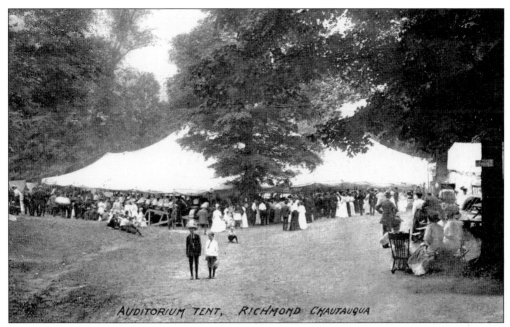

CHAUTAUQUA. The number of people and carriages pictured attests to the popularity of Richmond's Chautauqua.

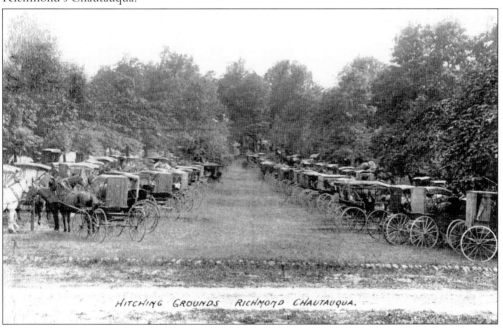

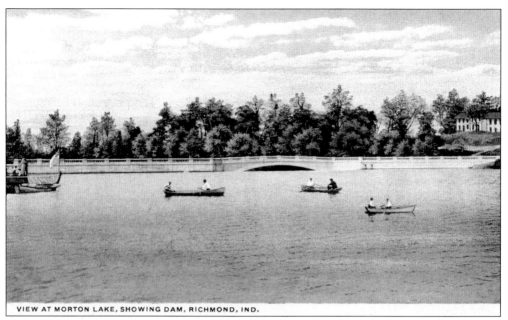

VIEW AT MORTON LAKE, SHOWING DAM, RICHMOND, IND.

MORTON LAKE. Morton Lake was an ill-fated Commercial Club venture in creating a summer resort northeast of the city. In 1913, the East Fork of the Whitewater was dammed at North Seventeenth Street, creating a recreational lake approximately a mile long, which included a swimming area, bathhouse, dancing pavilion, and various games. After it opened in June 1914, the park did seem to enjoy success for a few years, but by 1919, the endeavor had been abandoned. In 1920, the land was sold at public auction and the Morton Company disbanded.

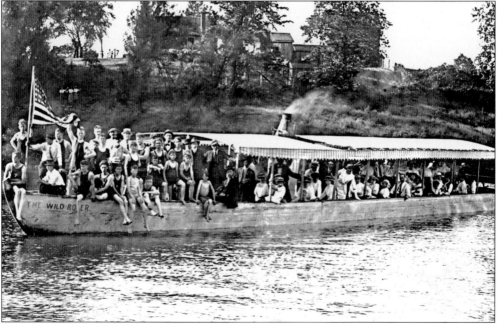

WILD ROVER. In addition to the small rowboats seen in the previous postcard, the lake boasted its own steamboat. Built and captained by a man named Henry Rogers, the *Wild Rover* ferried passengers the length of the lake. (Courtesy of Gary Batchelor.)

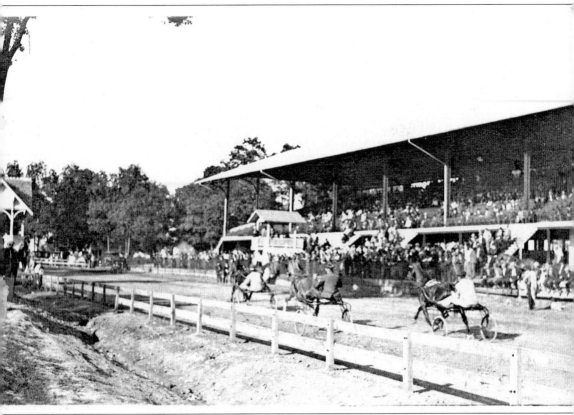

RICHMOND DRIVING PARK. For many years at the end of the 19th century, Richmond's fairground and entertainment center was the Driving Park. In 1890, several horse racing enthusiasts formed the Richmond Driving Park Association and acquired land east of the city. There, they laid out a one-mile track and built a grandstand, stables, and exhibition hall. The track was reputed to be the fastest in the country and was the first built with sloping sides. In addition to harness races, the park hosted bicycle and automobile races, and the infield contained a baseball field. In later years, Stanley Hayes bought the land, and the Driving Park area is now part of the Hayes Arboretum. (Courtesy of Gary Batchelor.)

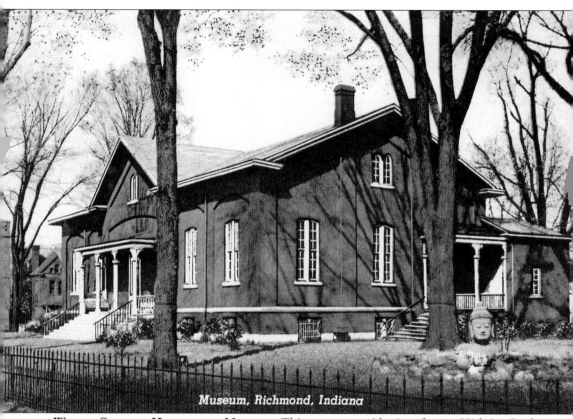

Museum, Richmond, Indiana

WAYNE COUNTY HISTORICAL MUSEUM. This museum resides in a former Hicksite Quaker Meeting House, which the congregation built in 1865 and occupied until the late 1920s. Declining membership prompted the congregation to donate the building and sell the property to the Wayne County Historical Society to be used as a museum. The president of the society at the time was Julia Meek Gaar, wealthy widow of W. W. Gaar. Julia Gaar was a frequent world traveler who always brought back items from her trips. Because she believed that the museum should not only preserve local history but give residents a chance to see bits of the world, the museum's collection includes many of her early, exotic donations. Shown in this postcard is the head of Buddha, which seems out of place in front of a Midwestern county museum. The collection also includes a Samurai suit of armor and Russian icons.

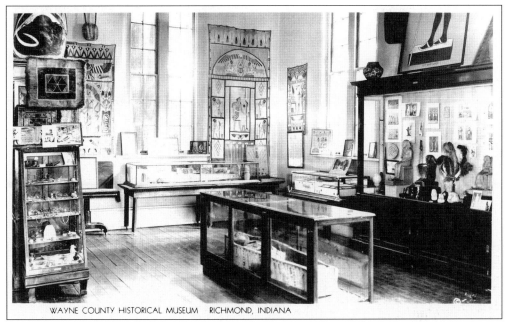

EGYPTIAN ROOM. Julia Gaar's most famous acquisition was the Egyptian mummy that she bought during her trip to Cairo in 1929. She paid $3,000 for it and had it sent home; however, in the meantime, the Egyptian government had stopped allowing mummies to leave the country. It required the influence of no less than Pres. Herbert Hoover to get the mummy released, making this one of the last, if not the last, mummy to leave Egypt. It has been the highlight of the museum visit for generations of Wayne County schoolchildren.

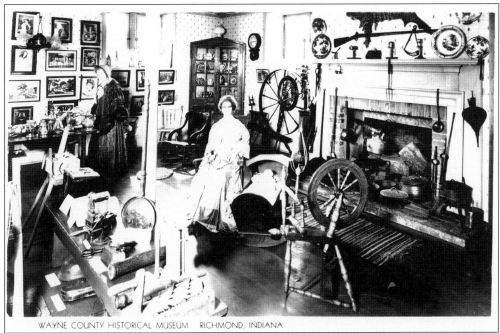

PIONEER KITCHEN. This more traditional display features the kinds of items one would find in a dwelling common in Richmond's early history.

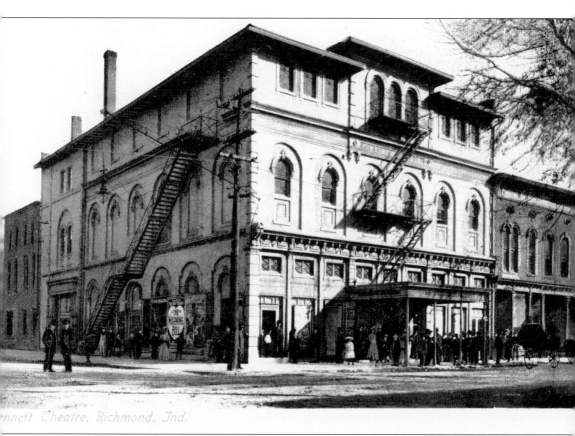

GENNETT THEATRE. The Bradley Theatre, located on the southeast corner of North A and Eighth Streets, burned down in September 1898. Clarence Gennett then bought the property in the summer of 1899 and had a new theater built in an amazing 92 days, opening on December 22, 1899. The Gennett Theatre was renovated in 1904, then again in 1916, to convert to a motion picture theater. Its name changed to the Washington in 1918 and later to the Lawrence. It was razed in 1935 to make way for a filling station.

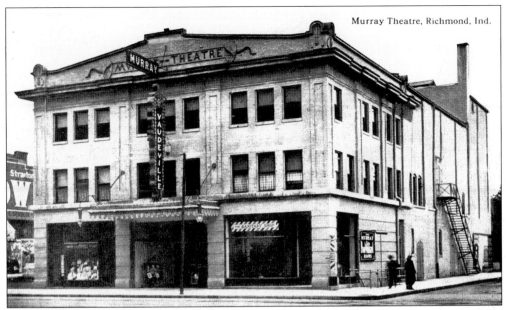

Murray Theatre, Richmond, Ind.

MURRAY THEATRE. Built in 1909 by Omar G. Murray, this theater is located on the southeast corner of Tenth and Main Streets. It was constructed as a vaudeville house and attracted some of the biggest names of the day. It closed in 1930, but reopened a year later as the Indiana Theater, showing movies. In 1952, the Richmond Civic Theatre began leasing the space for its live performances, then bought it in 1964. Today, again known as the Murray Theatre, it remains the home of the theater organization.

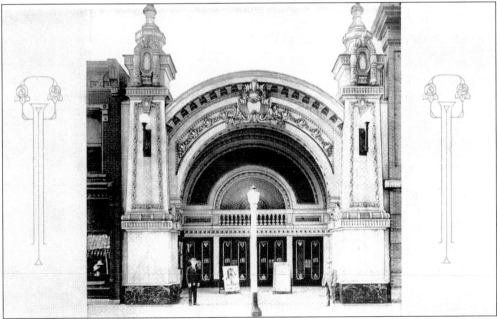

MURRETTE THEATRE. In 1912, Omar Murray built the Murrette Theatre, adjoining the Murray to the east. It was intended from the start to be a motion picture theater and remained so until the early 1930s. The building stood vacant for several years before being torn down in the late 1930s.

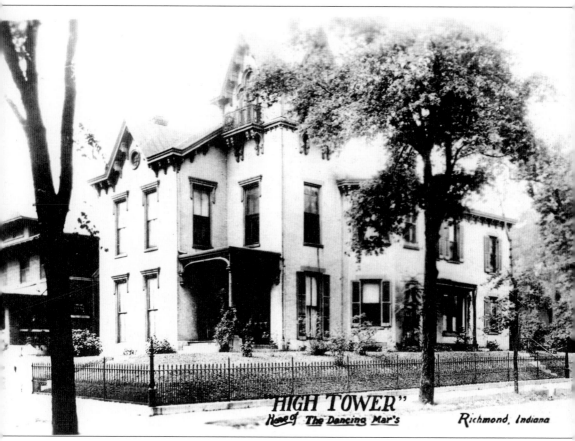

"HIGH TOWER"
Home of The Dancing Mar's Richmond, Indiana

HIGH TOWER. This residence, at 326 North Tenth Street, was the home of Charles and Gertrude Kolp and their daughter Elizabeth. After Charles's death in 1910, Gertrude, who ran a dancing school, formed a vaudeville act consisting of herself, Elizabeth, and Richmond native Peter Lichtenfels. Known as the Dancing Mars, the act was a success on the circuit for many years but broke up in 1918, when Peter enlisted in the army. Gertrude and Elizabeth returned to Richmond, opened their home to traveling performers, and printed advertising cards such as this. Elizabeth lived in the house until her death in 1969. Restored, the home is an anchor of the Starr Historic District. (Courtesy of the Earlham College Archives.)

Eight

HOSPITALS

Prior to the late 19th century, Richmond did not have a hospital as we think of it today. In 1884, St. Paul's Episcopal Church opened St. Stephen's Hospital on the northeast corner of North C and Eighth Streets. With only nine beds, it was inadequate for the needs of the growing community. New York financier and Richmond native Daniel G. Reid then came to the rescue, donating the largest part of the money required for a modern hospital.

Richmond is also home to the Richmond State Hospital. In the early 1880s, the state of Indiana planned to build three new asylums, and Richmond, Evansville, and Logansport won approval as the new sites. The location selected for this large project was, at the time, a mile west of the city and north of the National Road. The Eastern Indiana Hospital for the Insane, or Easthaven, as it was popularly known, opened in 1890. In 1927, its name was officially changed to the Richmond State Hospital.

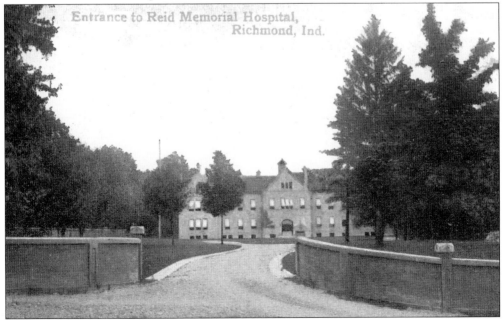

REID MEMORIAL HOSPITAL SEEN FROM CHESTER BOULEVARD.

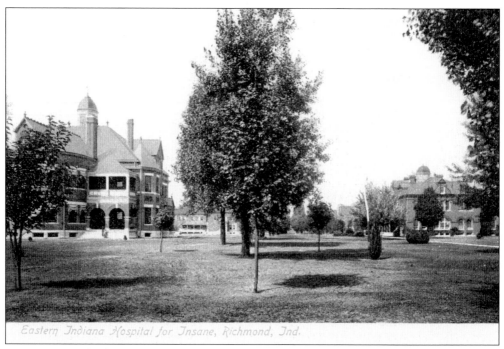

Eastern Indiana Hospital for Insane, Richmond, Ind.

EASTHAVEN. The hospital was built according to the cottage plan, in which patients lived in several smaller structures, rather than a large institutional building. In addition to being considered better for the patients' recovery, it was safer in case of fire.

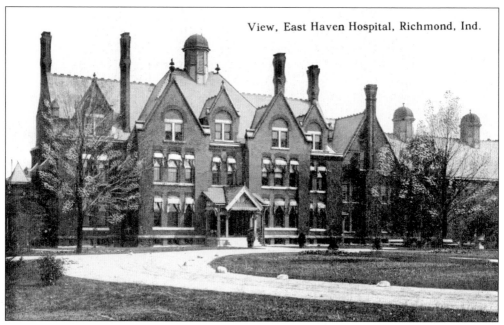

View, East Haven Hospital, Richmond, Ind.

ADMINISTRATION BUILDING. Located on the southern face of a U-shaped campus, the administration building looks very institutional, but stretching behind it to the north are the cottages intended to be more homelike. This is one of the few original buildings that is still in use.

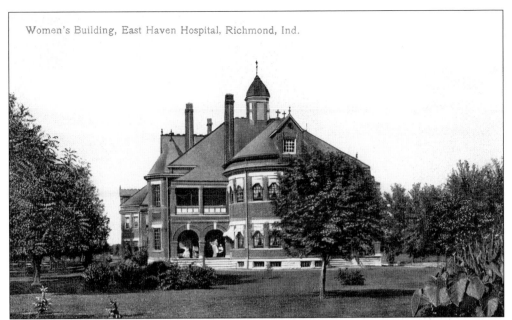

Women's Building, East Haven Hospital, Richmond, Ind.

WOMEN'S BUILDINGS. These views depict two of the cottages for women on the campus. (Above courtesy of Gary Batchelor; below courtesy of the Wayne County Historical Museum.)

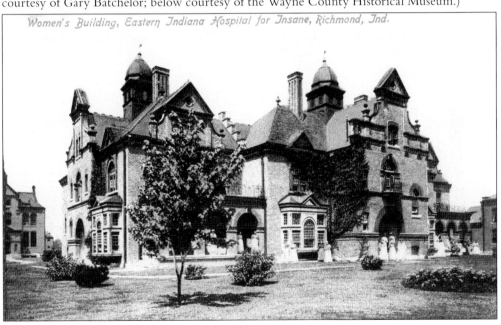

Women's Building, Eastern Indiana Hospital for Insane, Richmond, Ind.

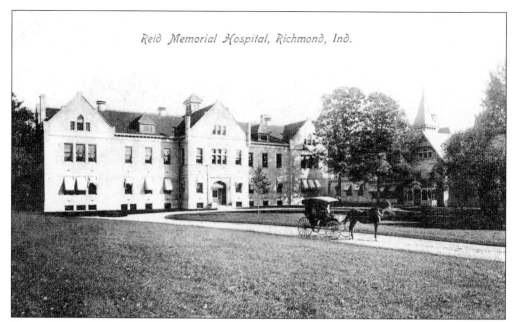

Reid Memorial Hospital, Richmond, Ind.

REID MEMORIAL HOSPITAL. In 1903, Daniel G. Reid purchased the property of Col. John F. Miller in Spring Grove, just north of the East Fork of the Whitewater. He donated most of the funding required for the land and the building as a memorial to his wife, Ella, who had died in 1899 and his son Frank, who had died of diphtheria in 1896 at age seven. Various organizations and individuals from the city furnished the rooms and wards. The building was dedicated on July 27, 1905. The house seen at the far right is Miller's home, which became the nurses' residence known as Rupe Hall after the first president of the board of trustees, John L. Rupe.

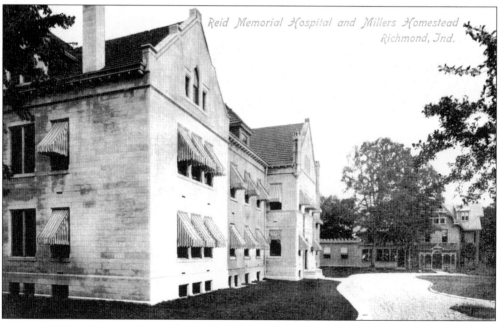

Reid Memorial Hospital and Millers Homestead Richmond, Ind.

RUPE HALL. Pictured here is another view of Miller's homestead, or Rupe Hall.

MILLER'S LAKE. When Colonel Miller owned the property, this lake was located at the bottom of the hill just south of his house, or roughly where most of the hospital is now. He had beautifully and carefully landscaped the lake with imported shrubs and flowers. Doctors, however, determined that the stagnant water was a breeding ground for bacteria that would be a detriment to patient recovery, so they ordered that the lake be filled in.

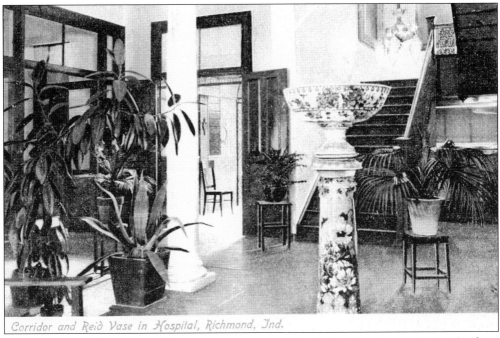

Corridor and Reid Vase in Hospital, Richmond, Ind.

REID HOSPITAL INTERIOR. Newspaper coverage of the dedication day stated that the five-and-a-half-foot-tall vase, which would be displayed in the main lobby for decades, was a gift of Rhea Reid, Daniel Reid's daughter.

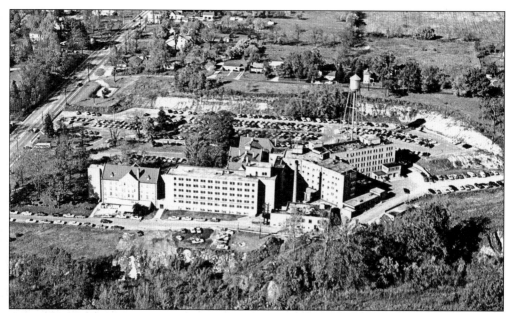

AERIAL VIEW OF REID MEMORIAL HOSPITAL. In the foreground of this mid–1960s view are Jenkins Hall (left), added in 1927, and the Reller Wing (center), added in 1958. (Courtesy of Ralph Pyle.)

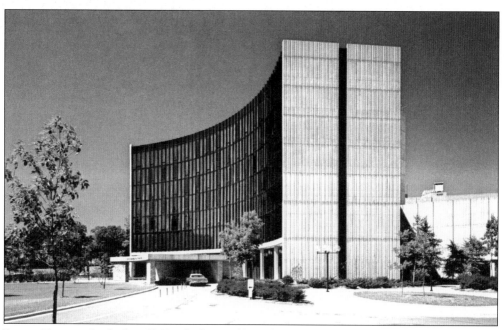

LEEDS TOWER. In the late 1960s, the hospital launched a major capital campaign to finance the most ambitious addition to date, the centerpiece of which is Leeds Tower, completed in 1973. This is still the main patient care facility. Currently, the new Reid Hospital complex is under construction on U.S. Route 27, just south of the Indiana University East campus.

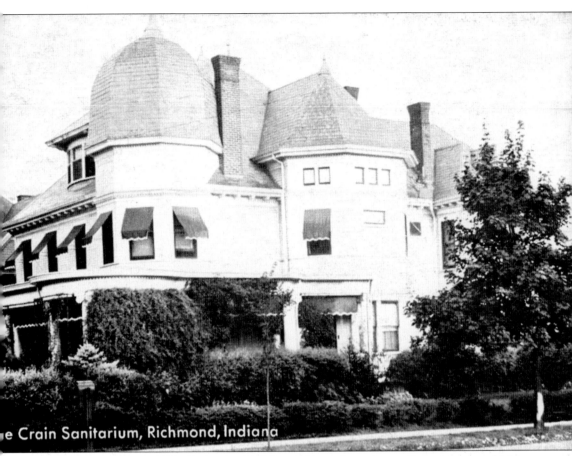

e Crain Sanitarium, Richmond, Indiana

CRAIN SANITARIUM. This distinctive building is located on the northwest corner of Main and Twenty-second Streets, just across from the Madonna of the Trail monument. Its existence as a sanitarium began in 1921 when Drs. Claude J. and Elizabeth Crain opened the doors to patients. They were osteopathic physicians who, according to the *Richmond Item* in July 1924, specialized in "the Dr. Porter Milk Diet, using certified raw Holstein milk from a selected herd of Holstein cows." The building remained a sanitarium until the early 1940s. (Courtesy of Gary Batchelor.)

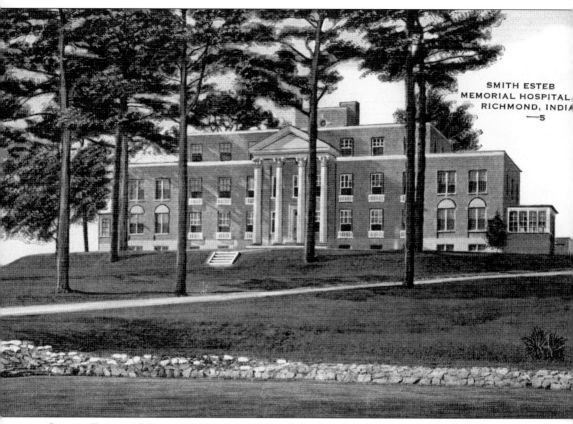

SMITH-ESTEB MEMORIAL HOSPITAL. In 1917, David and India Esteb donated to Wayne County the property of India's father, George Smith. The donation consisted of a farm of 235 acres and the home that faced Liberty Pike, now U.S. Route 27, near the southern border of the county. India was one of four sisters, and her three siblings had died of tuberculosis. The Estebs intended for the house to be converted into a tuberculosis sanitarium, but more than a decade of legal wrangling followed, and the new hospital was not dedicated until October 1934. It served as a tuberculosis hospital until January 1959, when its seven remaining patients were transferred to a facility in Fort Wayne. It next served as the Wayne County Home until April 1975, when its remaining residents were transferred to nursing homes and the building and grounds sold at auction.

Nine

STREET SCENES

So many postcards are simply snapshots of scenes around town. The buildings, businesses, dress of the pedestrians, modes of transportation, and other clues in these images can reveal a great deal about the history of a locale. This card is somewhat typical, because the most recorded street in town by far is Main and the most recorded corner is this one, at Eighth and Main Streets. In the shadows to the right is the Odd Fellows Building and in the sun is the towered corner of the Kelley-Hutchinson Building. The only conveyances are streetcars and horse-drawn vehicles, so this image was likely made in the first few years of the 20th century.

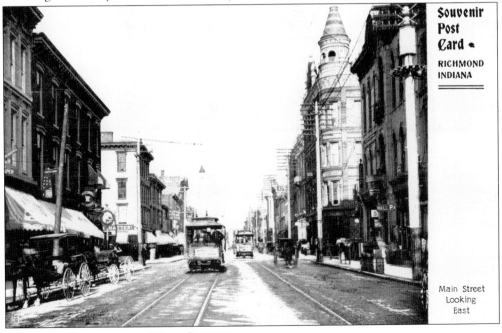

SOUVENIR POSTCARD OF MAIN STREET.

113

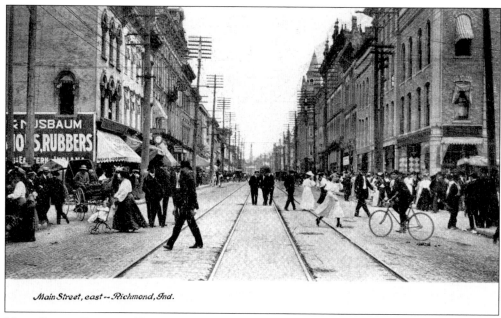

Main Street, east -- Richmond, Ind.

MAIN STREET LOOKING EAST FROM SEVENTH STREET. This view includes Neff and Nusbaum's shoe store on the northeast corner and the Colonial Building on the southeast corner. Main Street appears to be quite a bustling center of activity.

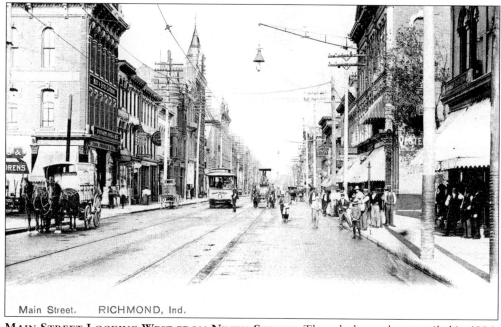

Main Street. RICHMOND, Ind.

MAIN STREET LOOKING WEST FROM NINTH STREET. Though the card was mailed in 1906, the photograph was likely taken earlier. (Courtesy of Gary Batchelor.)

114

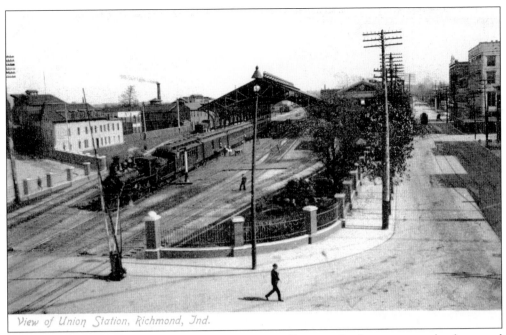

View of Union Station, Richmond, Ind.

NORTH E STREET LOOKING EAST FROM EIGHTH STREET. In the center are the depot and train shed, and to the right is the Arlington Hotel.

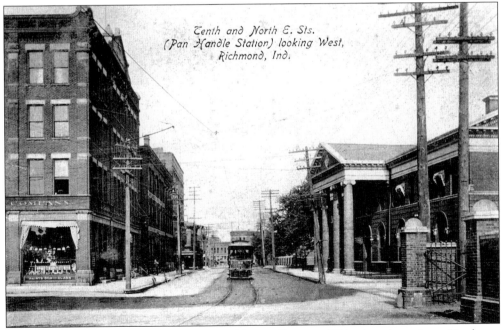

Tenth and North E. Sts. (Pan Handle Station) looking West, Richmond, Ind.

NORTH E STREET LOOKING WEST FROM TENTH STREET. This view shows Jones Hardware on the left and the depot on the right. (Courtesy of Gary Batchelor.)

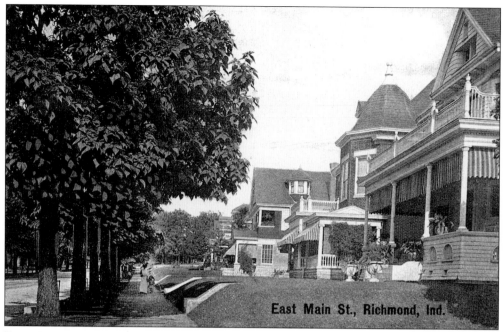

EAST MAIN STREET. This view, looking east from Nineteenth Street, depicts the area known as "Millionaire's Row" for its wealthy residents. (Courtesy of Gary Batchelor.)

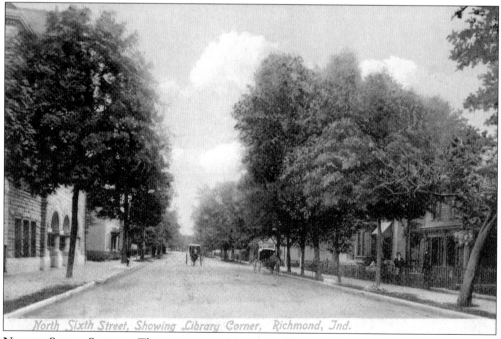

NORTH SIXTH STREET. The entrance to Morrisson-Reeves Library is just under the trees at the left.

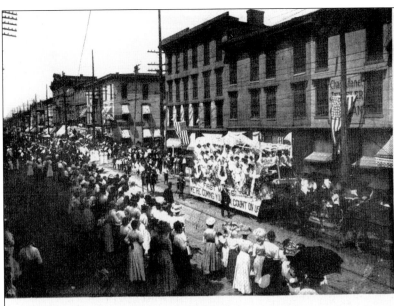

WAYNE COUNTY
SUNDAY SCHOOL
RALLY

July 25, 1908.

Sixty-nine Floats
in Parade;
5,360 Persons
in Parade.

City beautifully
decorated all
along line of
march.

Speaking at
Chautauqua
grounds,
Glen Miller,
by "Timothy
Standby" and
E. W. Halpenny.

Float of First M. E. Sunday School, carrying one hundred and two persons.

SUNDAY SCHOOL PARADE. A parade passes by in this view looking west at the 800 block of Main Street. (Courtesy of Gary Batchelor.)

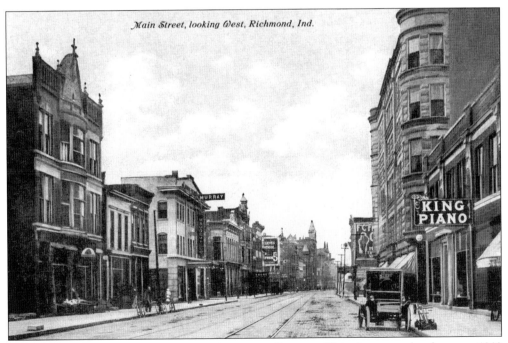

Main Street, looking West, Richmond, Ind.

MAIN STREET LOOKING WEST FROM ELEVENTH STREET. This view was taken between 1910 and 1912. The Murray Theatre is at the corner of Tenth, but the Murrette is not yet built. The Westcott Hotel stands on the north side of the street.

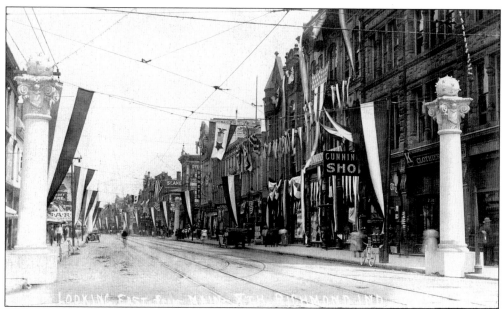

GAR Encampment. The Grand Army of the Republic was a Civil War veterans' organization, much like the Veterans of Foreign Wars. In 1911, the Indiana GAR held its annual encampment, or convention, in Richmond, and Main Street was decked out for the occasion. This eastward view of the 800 block of Main Street shows Knollenberg's Department Store on the left and the Kelley Hutchinson Building on the right. Note the electric streetcar cables above the street.

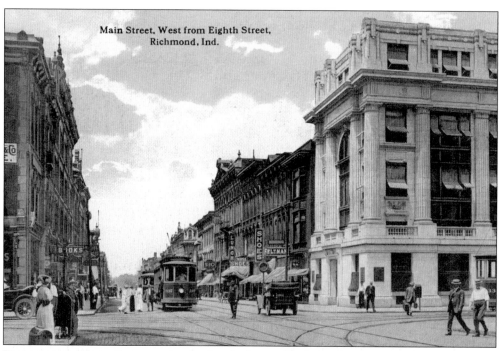

Eighth and Main Streets. In the days before traffic lights, it was not uncommon to see a policeman posted in the middle of the intersection directing traffic, especially at the busiest spot in town. This photograph was likely taken around 1915.

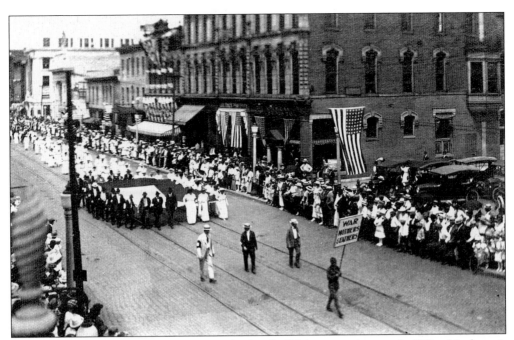

WORLD WAR I PARADE. The sign at the head of this procession reads, "War Mothers & Fathers," revealing that this scene at Ninth and Main Streets is likely from 1918. (Courtesy of Gary Batchelor.)

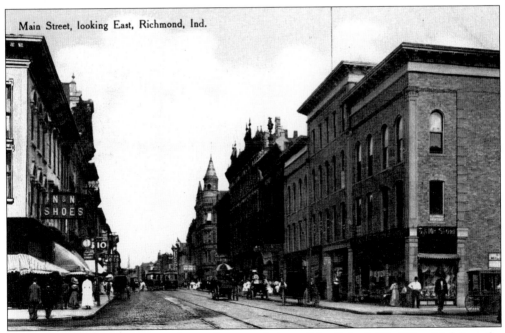

Main Street, looking East, Richmond, Ind.

COLONIAL BUILDING. This card provides a good view of the Colonial Building (right) on the southeast corner of Seventh and Main Streets.

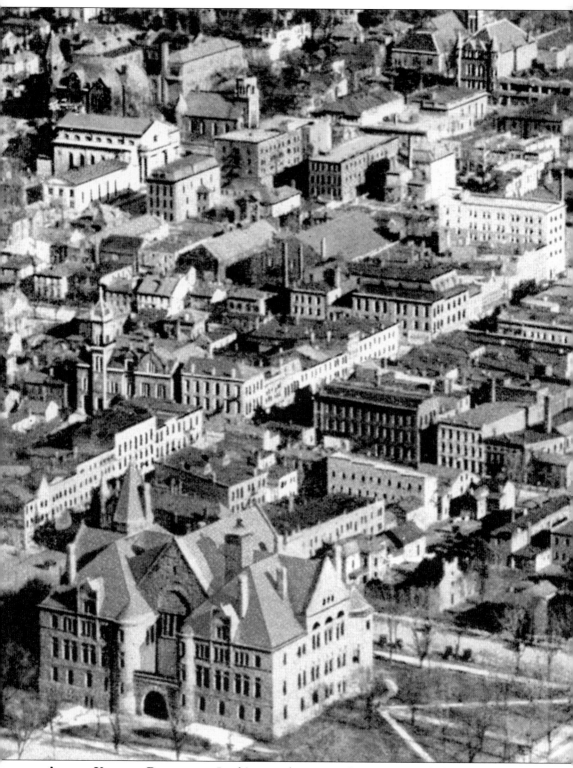

AERIAL VIEW OF RICHMOND. Looking northeast over downtown, with the Wayne County

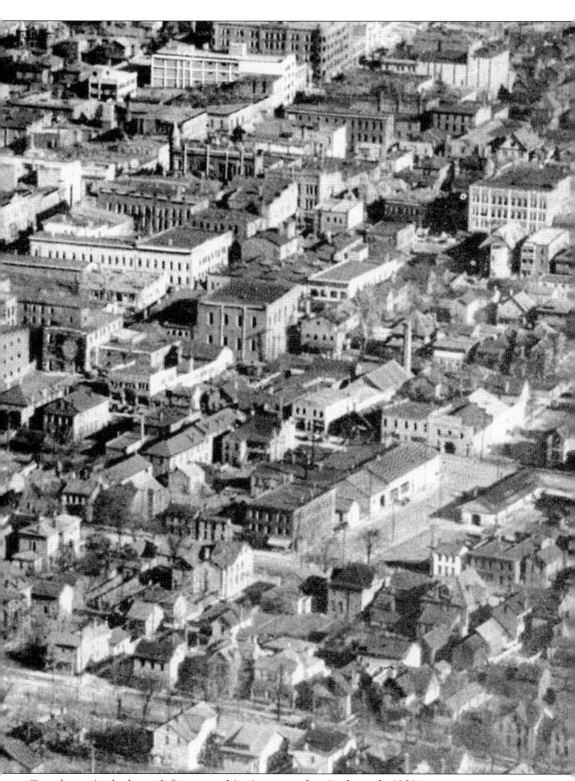

Courthouse in the lower left corner, this view was taken in the early 1920s.

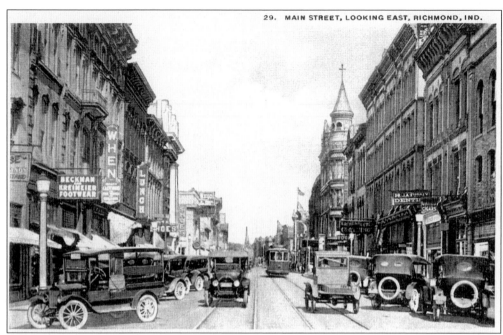

MAIN STREET LOOKING EAST IN THE 1920S. Automobiles and trucks are becoming more popular, outnumbering the interurban car in the center.

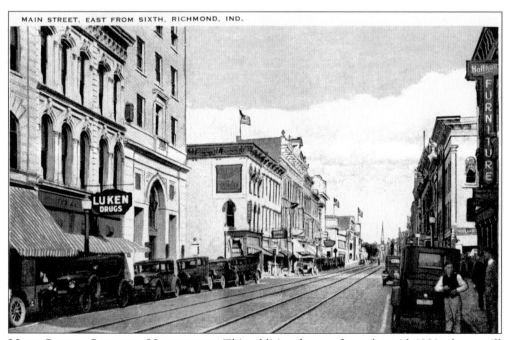

MAIN STREET, EAST FROM SIXTH, RICHMOND, IND.

MAIN STREET LOOKING NORTHEAST. This additional scene from the mid-1920s shows still more cars.

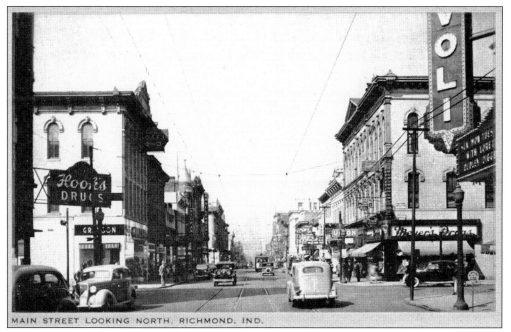

MAIN STREET LOOKING NORTH, RICHMOND, IND.

MAIN STREET LOOKING WEST FROM NINTH STREET. This 1938 view does not look north as it purports, but west from Ninth Street, showing, from left to right, Hook's Drugs, Grayson Clothing, Meyer's Drugs, and the Tivoli Theater. (Courtesy of Gary Batchelor.)

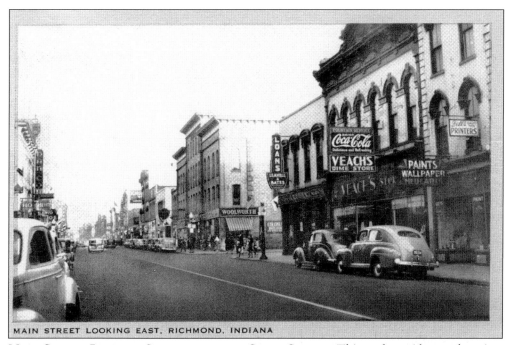

MAIN STREET LOOKING EAST, RICHMOND, INDIANA

MAIN STREET LOOKING SOUTHEAST FROM SIXTH STREET. This card provides another view of the Colonial Building at Seventh and Main Streets. In the early 1940s, Veach's was located at 627 Main.

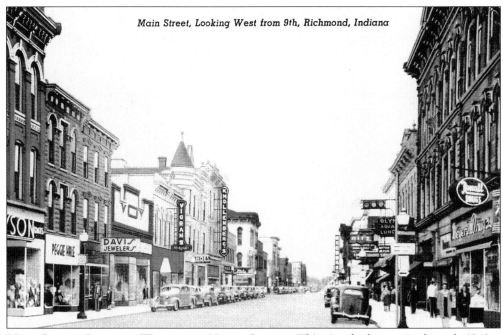

Main Street, Looking West from 9th, Richmond, Indiana

MAIN STREET LOOKING WEST FROM NINTH STREET. This view looks west in the early 1940s.

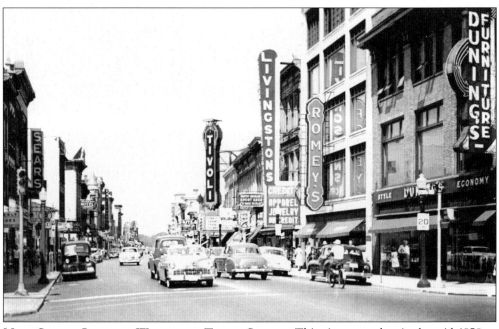

MAIN STREET LOOKING WEST FROM TENTH STREET. This view was taken in the mid-1950s.

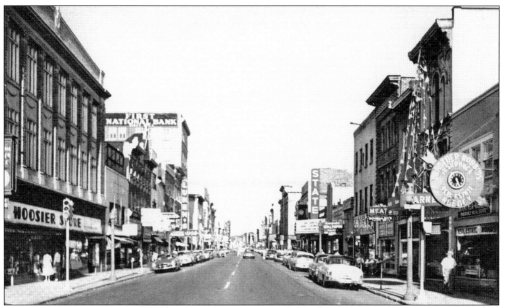

MAIN STREET, LOOKING EAST FROM SIXTH STREET. To the left is Bartel's Hoosier Store, and at the far end of the block is the First National Bank. The building at the far right is occupied by the Brantner-Robbins Insurance Company, but would become the home of Marting Arms Sporting Goods and Firearms. This building exploded on April 6, 1968, killing 41 people and destroying much of the surrounding blocks.

EXPLOSION MEMORIAL. "In memory of the forty-one persons who lost their lives in the tragic downtown explosion, April 6, 1968, and with everlasting gratitude to those who helped give rebirth of the city," reads the memorial. This monument was first located on the western edge of the Promenade. When the Promenade was removed and Main Street through the downtown area reopened to traffic in 1997, it was placed at the southwest corner of Fifth and Main Streets.

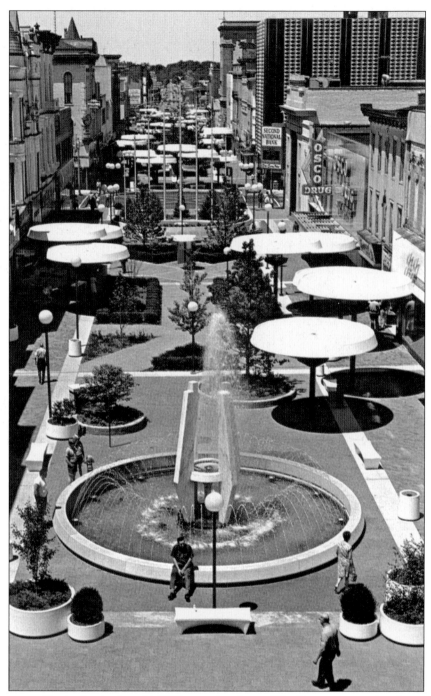

PROMENADE. Beginning in the mid–1960s, a pedestrian mall had been contemplated to revitalize the downtown area that had been losing business to suburban shopping centers for many years. The explosion gave this idea greater momentum, and the Redevelopment Commission went to work. Financed by federal funds and local dollars, construction began in September 1971. The new downtown was dedicated in June 1972. This view looks west from Ninth Street. (Courtesy of Ralph Pyle.)

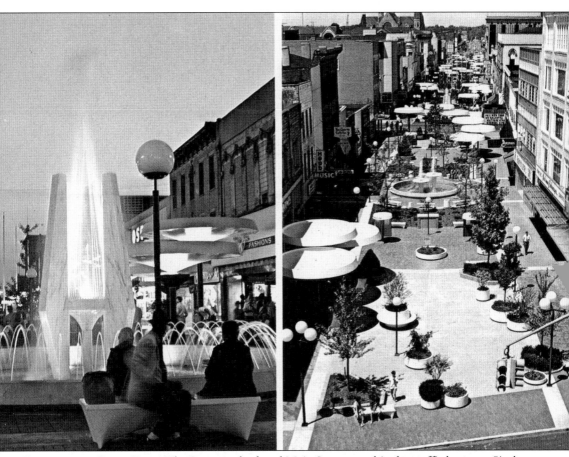

PROMENADE SPLIT VIEW. The Promenade closed Main Street to vehicular traffic between Sixth (later Fifth) and Tenth Streets. The resulting mall was beautified with landscaping, fountains, an amphitheater, and a series of large, circular, lighted canopies, not so affectionately dubbed "mushrooms." This split view shows one of the fountains and canopies lighted at dusk and an aerial view looking west from Tenth Street. (Courtesy of Ralph Pyle.)

INDEX